Drawing Cute
MANGA CHIBI

A Beginner's Guide to Drawing
Super Cute Characters

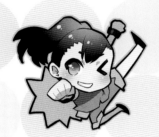

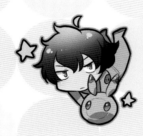

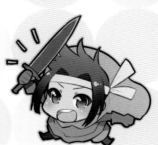

Ryusuke Hamamoto

TUTTLE Publishing

Tokyo | Rutland, Vermont | Singapore

CONTENTS

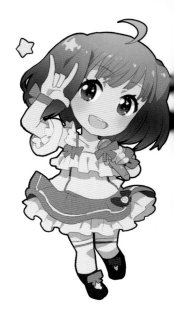

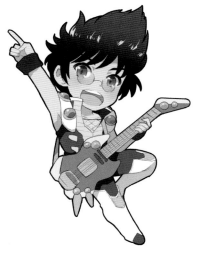

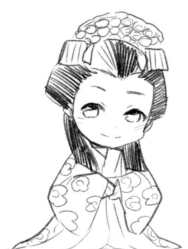

LESSON 4 CHIBI CHARACTERS

LESSON 5 CHIBI IN COLOR

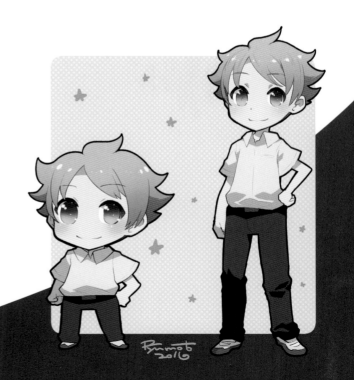

CALLING ALL CHIBI FANS!

WHEN I WAS IN ELEMENTARY SCHOOL, A LOT OF CHIBI-STYLE
CHARACTERS WERE POPPING UP IN ANIMATED SERIES AND MANGA.
I THINK THAT'S WHY I STARTED DOODLING LOTS OF CHUBBY LITTLE
CUTIES IN MY NOTEBOOK AROUND THAT TIME, RATHER THAN MORE
REALISTIC FIGURES.

SINCE BECOMING AN ADULT AND DRAWING LOTS OF CHARACTERS
OF ALL TYPES, I SEEM TO KEEP GETTING COMMISSIONS AND
ASSIGNMENTS TO CREATE THE CHIBIS THAT PREOCCUPIED MY YOUTH.
I WONDERED WHY I WAS THE CHOSEN ONE—WHEN THERE ARE SO MANY
OTHER ACCOMPLISHED ILLUSTRATORS OUT THERE—AND WAS SURPRISED
WHEN THE PEOPLE HIRING ME EXPLAINED THEY WANTED SOMEONE WHO
COULD MAKE THESE EXAGGERATED AND CARICATURIZED CHARACTERS
LOOK CUTE.

I NEVER THOUGHT OF BEING ABLE TO DRAW CHIBIS AS ANYTHING
SPECIAL. I THOUGHT ANYONE COULD DRAW THEM AND THAT IF I COULD
PRODUCE THEM, THEN IT CAN'T BE THAT DIFFICULT.

WHEN I STARTED TO ASK AROUND—A WRITER FRIEND AND THE
STUDENTS I WAS TEACHING—I REALIZED THAT MAKING THESE
CHARACTERS LOOK CUTE MAY SEEM SIMPLE, BUT APPEARANCES CAN
BE DECEIVING. THEY SAID THEY TRIED TO REPLICATE THE CHIBI STYLE,
BUT THEIR WORK NEVER LOOKED QUITE RIGHT. THEY MISTAKENLY
CONCLUDED THAT THEY WEREN'T ANY GOOD AT IT.

I PRODUCED THIS GUIDE TO SERVE AS A STARTING POINT FOR BUDDING
ARTISTS WHO WANT TO DRAW CHIBI CHARACTERS BUT DON'T THINK
THEY HAVE THE SKILLS OR TALENT. NONSENSE: OF COURSE YOU DO!
WHETHER IT'S CREATING SIMPLIFIED OR EXAGGERATED CHARACTERS,
THERE'S A CHIBI STYLE MADE JUST FOR YOU.

— RYUSUKE HAMAMOTO

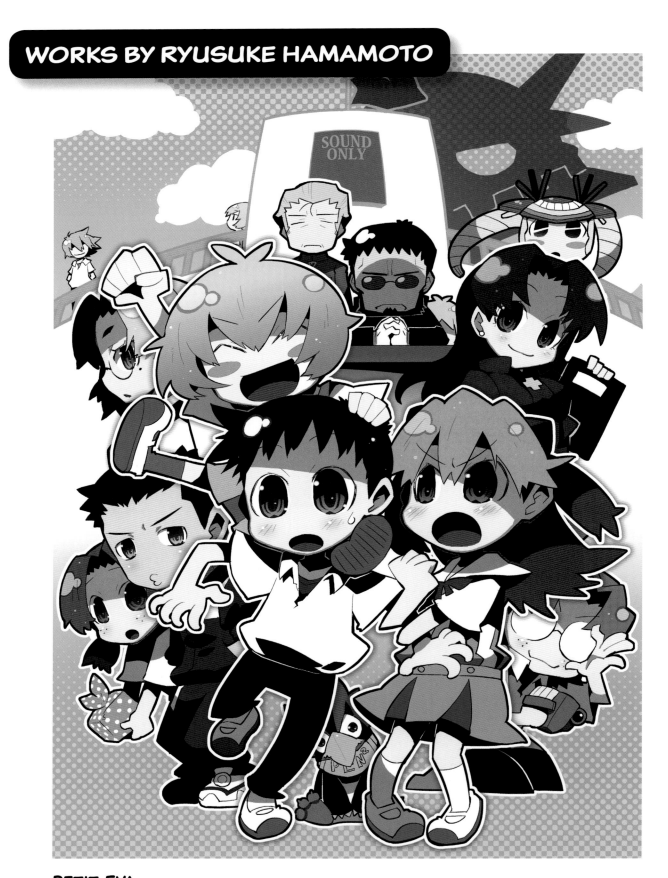

PETIT EVA

A still from the anime series *Neon Genesis Evangelion*.

PETIT EVA (C-STYLE)

Illustration from the release of *Evangelion: 3.0 You Can (Not) Redo*.
The C-style line added new dimensions to the illustrations.

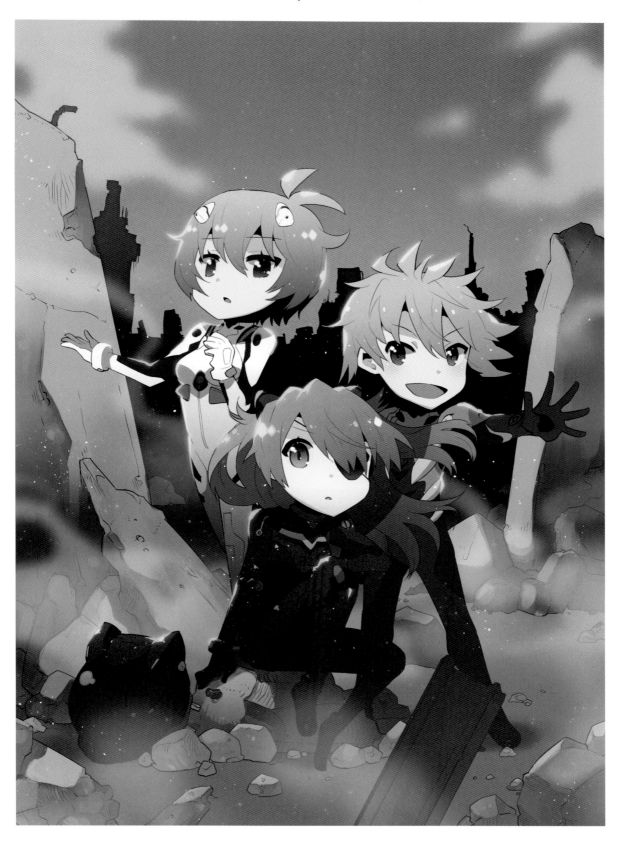

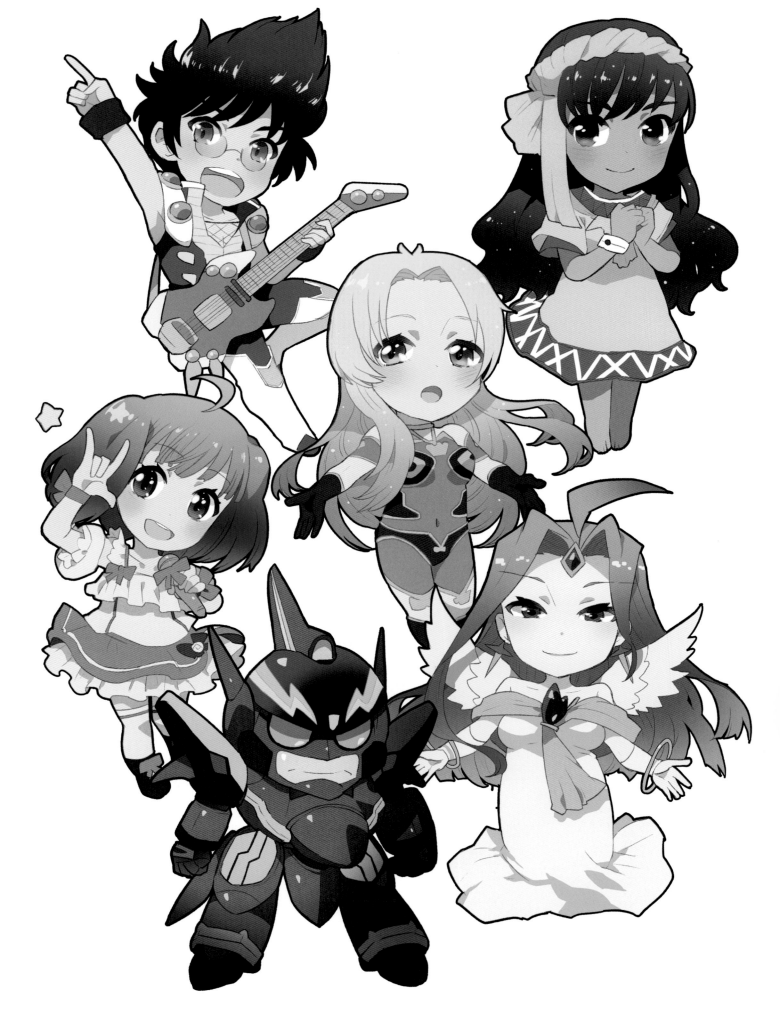

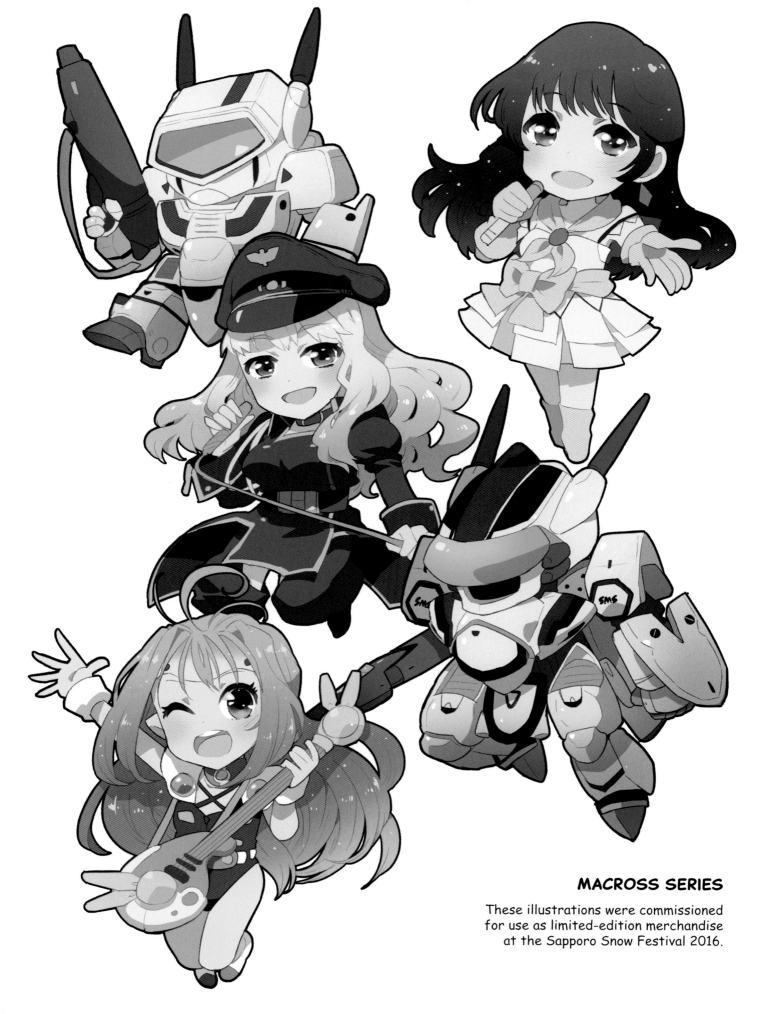

MACROSS SERIES

These illustrations were commissioned for use as limited-edition merchandise at the Sapporo Snow Festival 2016.

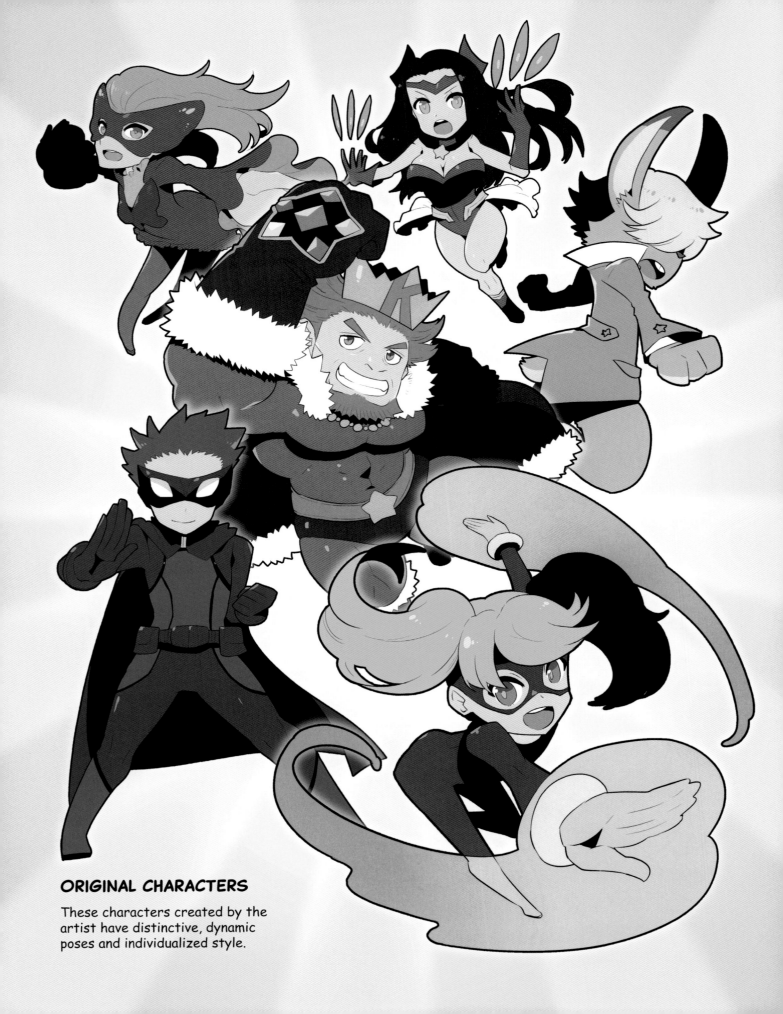

ORIGINAL CHARACTERS

These characters created by the artist have distinctive, dynamic poses and individualized style.

ORIGINAL CHARACTERS FOR BOOKS

Book illustrations showing characters with differing proportions.
The illustration process is explained in Lesson 5.

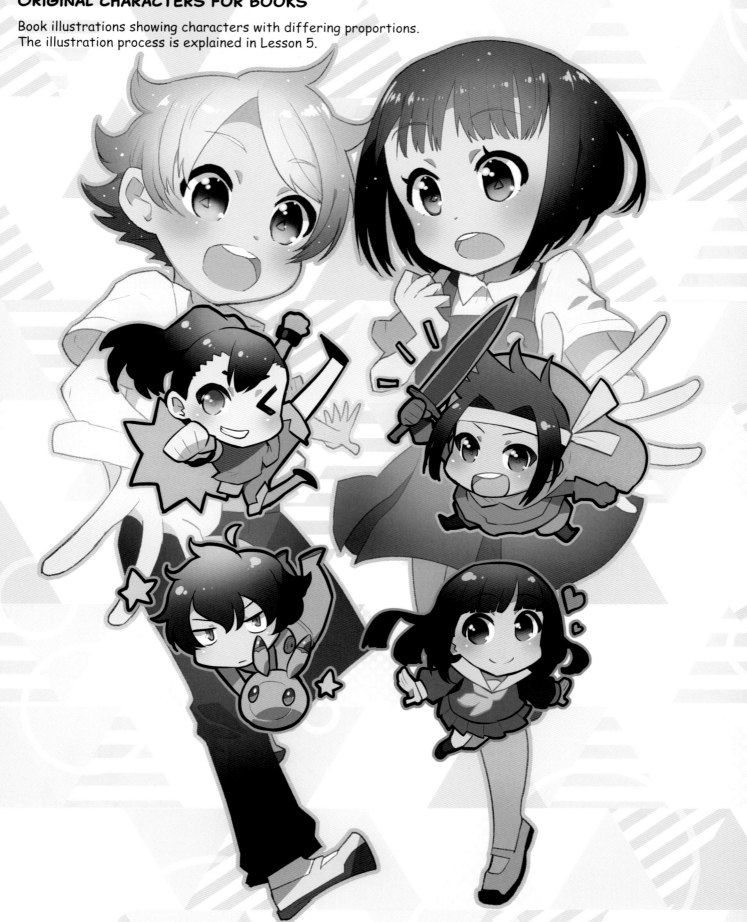

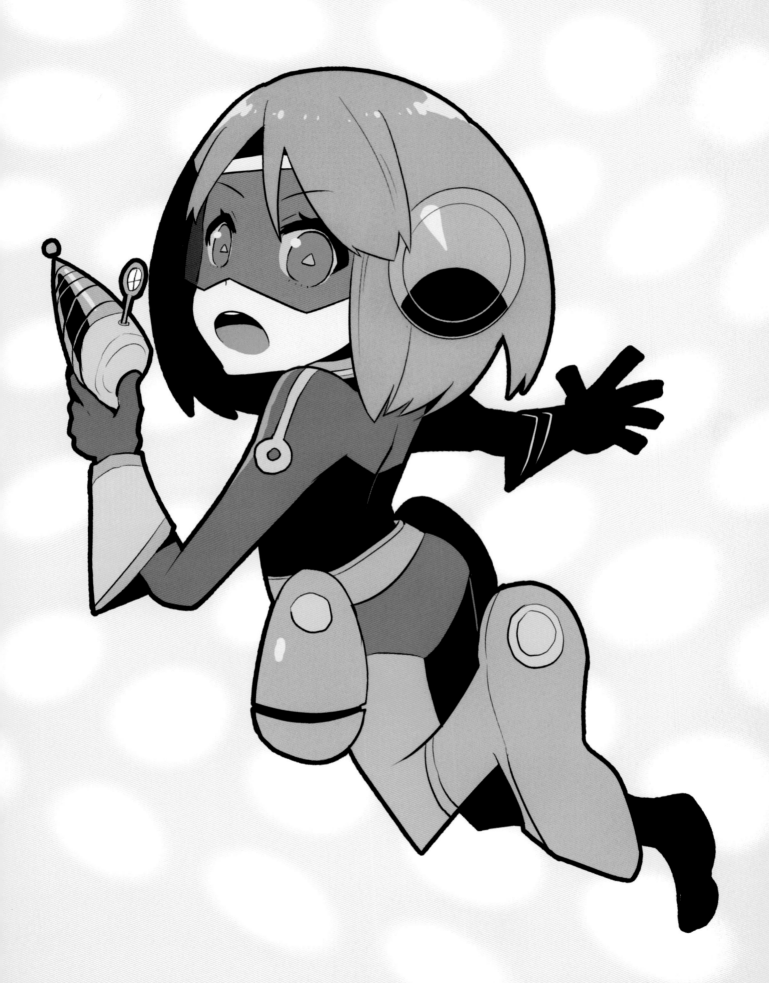

CHIBI BASICS

CHANGING EXPRESSION THROUGH PROPORTION

IN THIS CHAPTER, WE'LL LOOK AT THE BASIC METHODS FOR DRAWING CHIBI CHARACTERS RANGING IN HEIGHTS FROM 1.5 TO 4 TIMES THE SIZE OF THEIR HEADS. THIS WAY YOU'LL BE ABLE TO COMPARE THE VARIOUS CHARACTERISTICS OF DIFFERENT PROPORTIONS AT A GLANCE. THE TRICK TO GETTING IT RIGHT IS TO REMEMBER THAT THE SMALLER THE BODY IN PROPORTION TO THE HEAD, THE SIMPLER THE DETAILS SHOULD BE.

1:6 head-to-body ratio

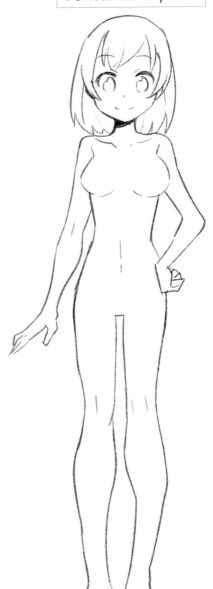

Emphasizing Changes in Expression

Although all the drawings use chibi techniques, the depiction of the limbs and torso becomes simplified as the head-to-body ratio increases. On a figure whose body is four times the height of her head, finger movement is perceptible, but on a figure with a high head-to-body ratio, hand details are significantly reduced.

1:4 head-to-body ratio 1:2 head-to-body ratio

1:4 head-to-body ratio

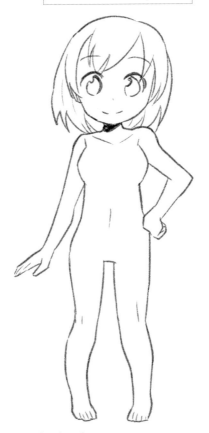

1:3.5 head-to-body ratio

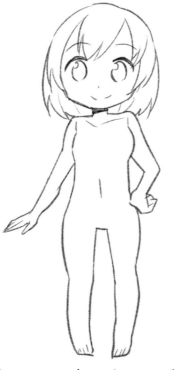

In comic book illustrations, figures are generally six heads tall. For women, the swelling of the chest and the curve of the waist are clearly defined.

Although the figure is a caricature, it maintains its femininity. Six heads tall is an ideal choice for depicting children.

The eyes are large in comparison with the face and the joints become simplified. On a figure with these proportions, it's still possible to define the gender.

It's All in the Eyes

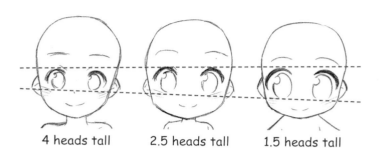

4 heads tall 2.5 heads tall 1.5 heads tall

As the head-to-body ratio increases, the face becomes more compact, with the eyes taking up more room. The eyes are important features for characters' expressions, so make sure they are balanced with the specific head-to-body ratio you're using.

1.5 heads tall

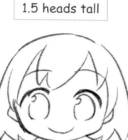

The sense of the character's gender is lost, replaced instead by a generic "cuteness." Often when drawing the hands, even the thumb is left out.

3 heads tall

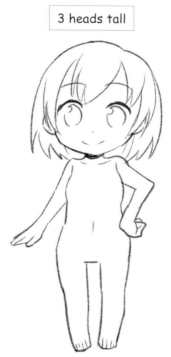

2.5 heads tall

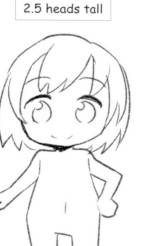

2 heads tall

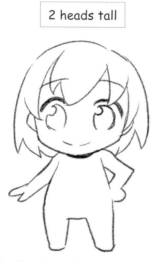

At this height, it becomes difficult to express age via the physique. The legs become shorter, and the neck all but disappears. The joints are also simplified.

This is around the height and physique for mascot-type figures. Gender is impossible to define through the physique, so it's expressed through hairstyle and clothing.

The head and body are the same size and you're not able to draw body parts in detail. The eyes take up much more room on the face, and the nose is omitted entirely.

PROPORTIONS FOR FIGURES 1.5 HEADS TALL

AT 1.5 HEADS TALL, BODY PARTS ARE SMALL AND IT'S PRACTICALLY IMPOSSIBLE TO DEFINE A CHARACTER'S GENDER. BECAUSE OF THIS, THE THICKNESS OF THE LIMBS AND OTHER FEATURES BECOMES CRUCIAL. LET'S TAKE A LOOK AT THE DIFFERENCES.

Front on

The thickness of the limbs helps express whether a character is male or female. Large, blunt limbs appear masculine, while tapered limbs seem more feminine.

WHEN THE CHARACTER IS 1.5 TO 2 HEADS TALL, INCORPORATING CHIBI TECHNIQUES, SUCH AS LARGE EYES, REALLY MAKES IT STAND OUT.

TIP

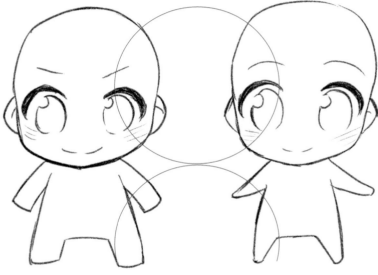

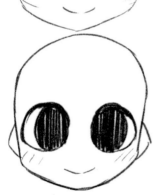

At this height, the ends of the hands and feet are significantly simplified or omitted. Doing this makes for a more adorable, caricaturized look.

Side view

Define the tip of the nose when drawing the side view. The stomach protrudes in the way a baby's would.

TIP

THE BODY IS POSITIONED BELOW THE CENTER OF THE HEAD. IF THE HEAD IS OFF-CENTER, IT'LL LOOK AS IF IT'S ABOUT TO FALL OFF.

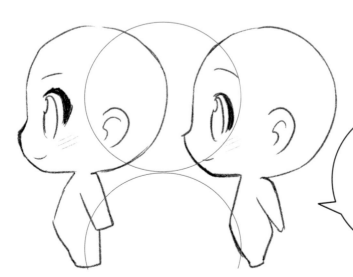

View from below

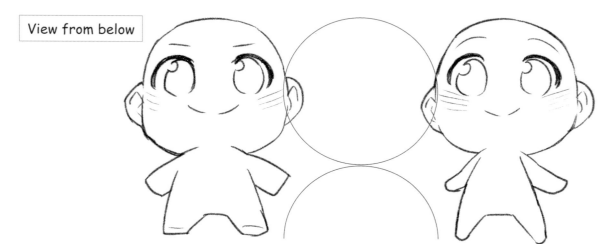

The physique doesn't alter much when seen from below,
but as the drawing is distorted, the chin is omitted.

Bird's-eye view

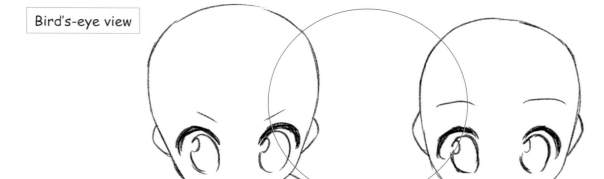

There's little change when the figure is shown from above,
but the overhead angle means the crown of the head is larger.

Rear view

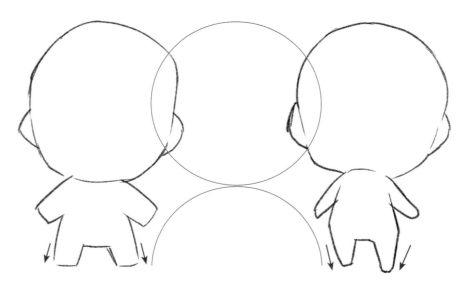

Draw characters' legs angled outward to express energy and momentum or angle legs inward to
convey an unassuming, adorable impression.

PROPORTIONS FOR FIGURES 2 HEADS TALL

AT TWO HEADS TALL, THE LIMBS BECOME LONGER, BUT THE FIGURE IS BASICALLY THE SAME AS AT 1.5 HEADS TALL. THE WAYS TO DIFFERENTIATE BETWEEN GENDERS, SUCH AS THE THICKNESS OF THE LIMBS AND OTHER PROPORTIONS, ARE ALSO VERY SIMILAR.

Front view

As for a figure 1.5 heads tall, taper the limbs for female characters and make them blunt for male characters, accompanied by a sturdier body.

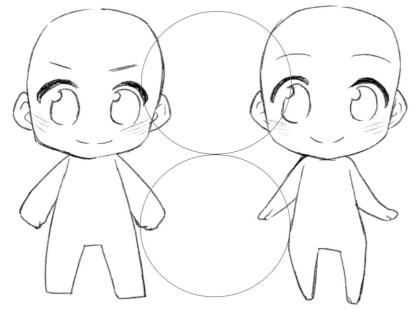

Making male characters' limbs straight creates the appearance of strength. For an androgynous male character, make the limbs thinner over all.

Turn female characters' hands outward slightly for an adorably girlish look. Positioning the toes to turn slightly inward also makes for a cute effect.

Side view

From the front on, the neck is concealed by the chin, but when viewed from the side it becomes apparent, although still very short. This is the main difference between figures of this height and those that are 1.5 heads tall.

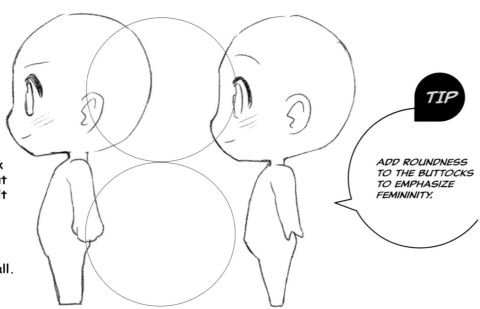

TIP

ADD ROUNDNESS TO THE BUTTOCKS TO EMPHASIZE FEMININITY.

View from below

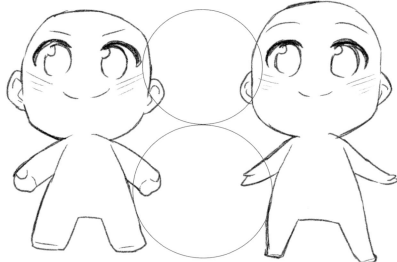

When showing the figures from below, draw the limbs for male and female characters differently. The male's feet should be firmly planted.

Bird's-eye view

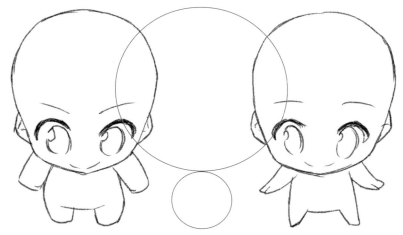

Viewed from above, the legs can be seen barely extending from the torso. Differentiate between male and female feet through their shape.

Rear view

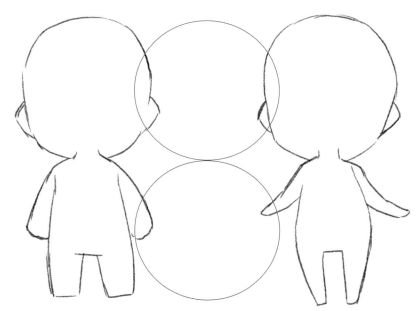

The figures' bottoms are about the same size, but make the male's look larger by drawing his legs slightly farther apart.

PROPORTIONS FOR FIGURES 2.5 HEADS TALL

THIS IS THE MOST ADAPTABLE PROPORTION TO USE WHEN DRAWING CHIBI CHARACTERS. IT'S EASY TO INCORPORATE CLOTHES AND ACCESSORIES AND SKILFULLY USE THE SENSE OF DISTORTION AS WELL AS THE CHARACTERS' INDIVIDUALITY TO CUTE EFFECT.

Front view

For figures at this height, don't pay too much attention to the joints, but create limbs with smooth lines.

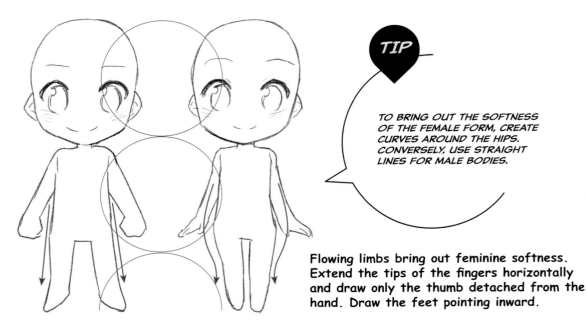

TIP

TO BRING OUT THE SOFTNESS OF THE FEMALE FORM, CREATE CURVES AROUND THE HIPS. CONVERSELY, USE STRAIGHT LINES FOR MALE BODIES.

Flowing limbs bring out feminine softness. Extend the tips of the fingers horizontally and draw only the thumb detached from the hand. Draw the feet pointing inward.

Make the arms and legs straight and dynamic for a masculine look. Taper the wrists and draw in simplified hands.

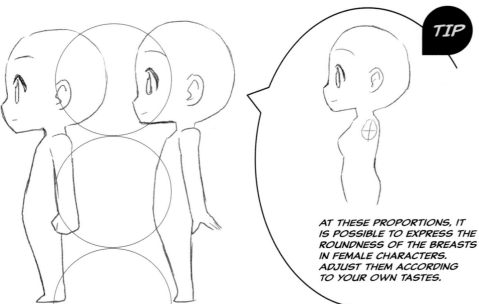

TIP

Side view

Don't draw the stomach flat; make it stick out a little. This results in a faintly child-like look, an adorable effect particular to the chibi style.

AT THESE PROPORTIONS, IT IS POSSIBLE TO EXPRESS THE ROUNDNESS OF THE BREASTS IN FEMALE CHARACTERS. ADJUST THEM ACCORDING TO YOUR OWN TASTES.

View from below

The figure takes on a slightly more dimensional appearance. Males have more of a heavy, solid look than females.

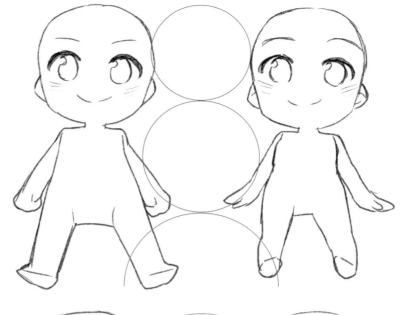

Bird's-eye view

The body becomes smaller from this perspective. As you draw, make sure the figure doesn't become too realistic.

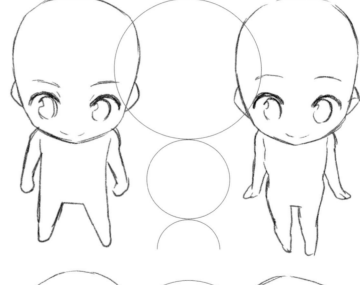

Rear view

The arms are attached to the body not precisely at the sides, but slightly to the front. At this height, there's little difference between male and female figures.

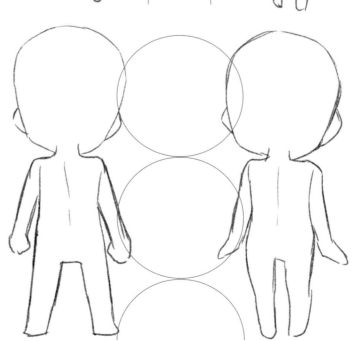

PROPORTIONS FOR FIGURES 3 HEADS TALL

AT THREE HEADS TALL, YOU CAN SHOW NOT ONLY THE DIFFERENCE BETWEEN GENDERS BUT ALSO DIFFERENCES IN AGE AND PHYSIQUE, GREATLY EXTENDING THE RANGE OF POSSIBILITIES. WHILE THE FIGURES ARE STILL ADORABLE, AT THIS HEIGHT, YOU'RE ABLE TO CAPTURE AND EXPRESS FINER DETAILS.

Front view

When drawing males, give the shoulders and hips a slightly squared-off silhouette. Conversely, draw females with curves and roundness in mind.

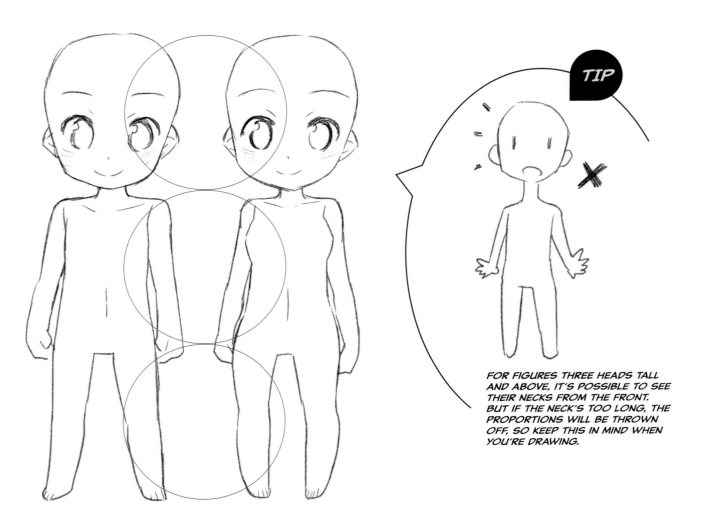

TIP

FOR FIGURES THREE HEADS TALL AND ABOVE, IT'S POSSIBLE TO SEE THEIR NECKS FROM THE FRONT. BUT IF THE NECK'S TOO LONG, THE PROPORTIONS WILL BE THROWN OFF, SO KEEP THIS IN MIND WHEN YOU'RE DRAWING.

At three heads tall, the head, torso and legs are all a similar length. For the legs of female characters, maintain the slenderness but give them a roundness as well.

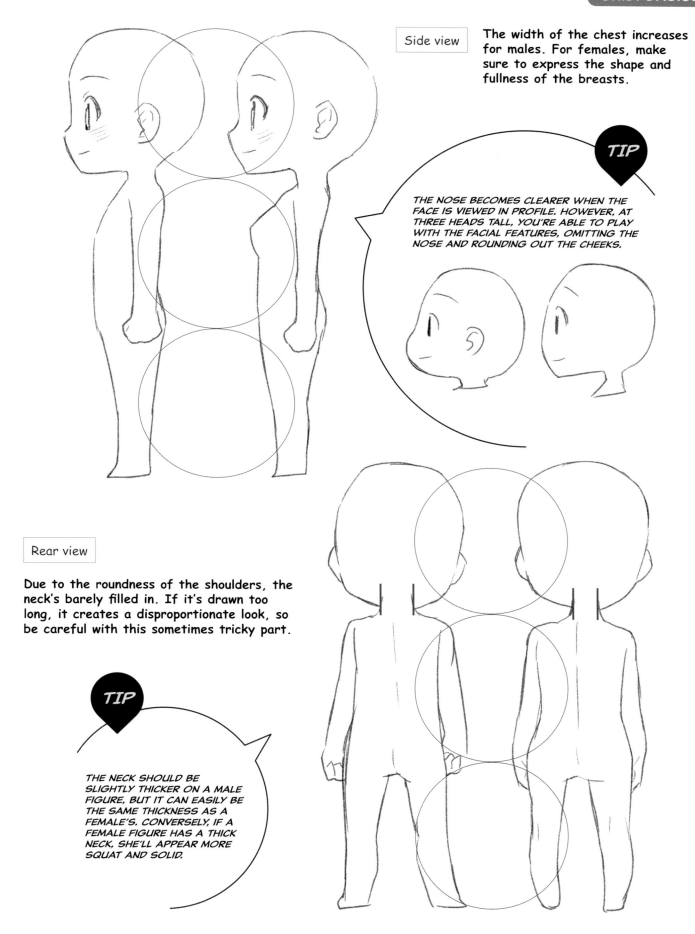

Side view

The width of the chest increases for males. For females, make sure to express the shape and fullness of the breasts.

TIP

THE NOSE BECOMES CLEARER WHEN THE FACE IS VIEWED IN PROFILE. HOWEVER, AT THREE HEADS TALL, YOU'RE ABLE TO PLAY WITH THE FACIAL FEATURES, OMITTING THE NOSE AND ROUNDING OUT THE CHEEKS.

Rear view

Due to the roundness of the shoulders, the neck's barely filled in. If it's drawn too long, it creates a disproportionate look, so be careful with this sometimes tricky part.

TIP

THE NECK SHOULD BE SLIGHTLY THICKER ON A MALE FIGURE, BUT IT CAN EASILY BE THE SAME THICKNESS AS A FEMALE'S. CONVERSELY, IF A FEMALE FIGURE HAS A THICK NECK, SHE'LL APPEAR MORE SQUAT AND SOLID.

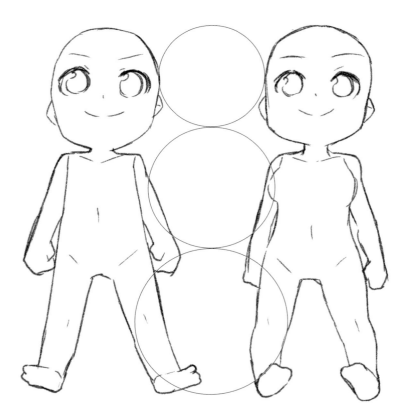

View from below

Once the figure gets to three heads in height, various body parts can be drawn more clearly and facial and physical proportions change significantly when viewed from below.

TIP

BE CONSCIOUS OF THE STRAIGHT LINES USED FOR MALE CHARACTERS' HIPS AND THE ROUNDNESS OF FEMALE CHARACTERS' CHESTS AND HIPS.

Bird's eye view

As when drawing the figure viewed from below, pay attention to getting the balance of body parts right. The figure is being seen from above, so make the legs smaller and shorter and bring the parts of the face down lower.

TIP

THE CIRCLES DECREASE IN DIAMETER, AS THEY DESCEND TO THE CHARACTER'S LOWER EXTREMITIES.

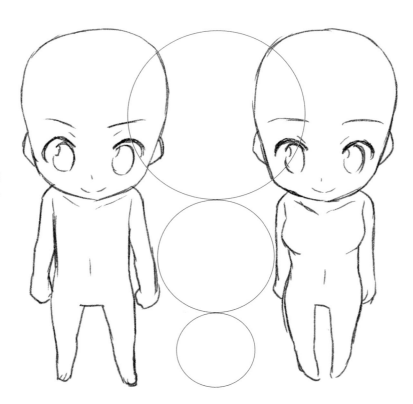

EXPRESSION AND MOTION IN FIGURES 3 HEADS TALL

At this height, the body can be drawn in different ways so that the range of expression increases. Pay close attention to the details in order to achieve the kinds of characters you want.

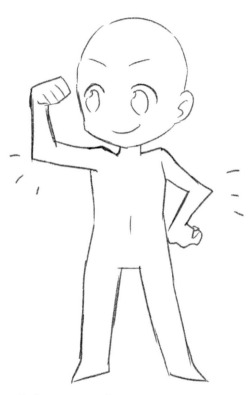

Making joints firm and straight creates a sharp impression suited to male characters and characters who perform large, showy actions.

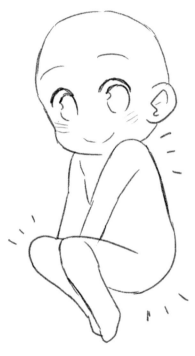

Creating roundness at the joints introduces a sense of suppleness and flexibility. Use this to emphasize cuteness or femininity.

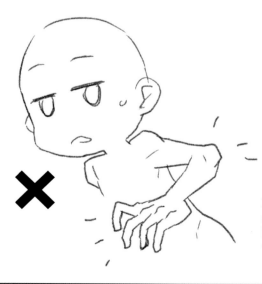

If joints are drawn in an overly realistic style, the charm of the character is lost. It's extremely important to draw the joints in keeping with the chibi style.

PROPORTIONS FOR FIGURES 3.5 HEADS TALL

THERE'S A SIGNIFICANT INCREASE IN DETAIL FOR FIGURES AT THIS HEIGHT. IT BECOMES EASIER TO CREATE THE PHYSIQUE, FACIAL EXPRESSIONS AND OTHER FEATURES THAT DEFINE YOUR CHARACTERS.

Front view

While figures at this height appear more realistic than those less than three heads tall, don't fill in too much detail. Remember the chibi aesthetic when giving your figures exaggerated or overdefined expressions.

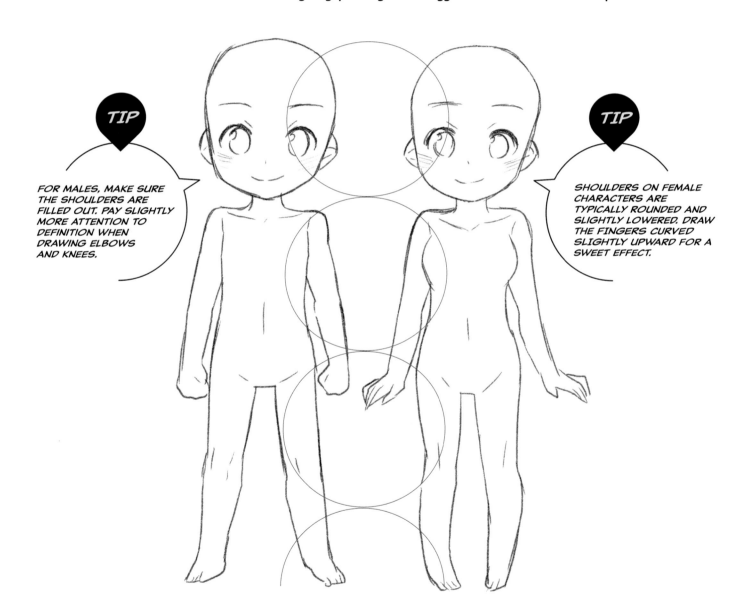

TIP

FOR MALES, MAKE SURE THE SHOULDERS ARE FILLED OUT. PAY SLIGHTLY MORE ATTENTION TO DEFINITION WHEN DRAWING ELBOWS AND KNEES.

TIP

SHOULDERS ON FEMALE CHARACTERS ARE TYPICALLY ROUNDED AND SLIGHTLY LOWERED. DRAW THE FINGERS CURVED SLIGHTLY UPWARD FOR A SWEET EFFECT.

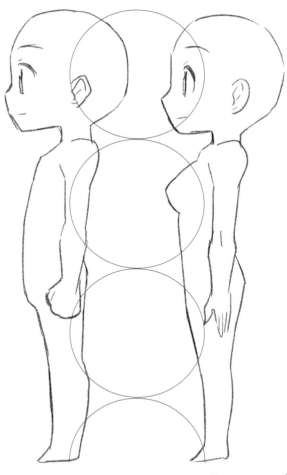

Side view

Pay attention to the line of the back, hips and around the buttocks when drawing the figure from the side.

TIP

MAKE SURE TO BALANCE THE LEGS SO THE FEET ARE FIRMLY ON THE GROUND. THIS WILL LEND YOUR CHARACTER A SLIGHTLY MORE REALISTIC LOOK.

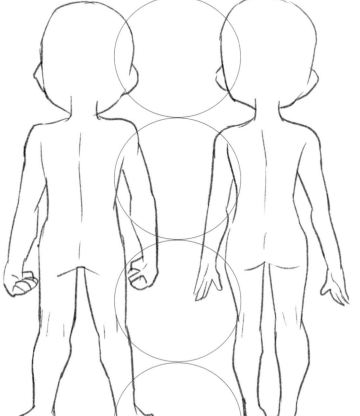

Rear view

From this angle, the difference in the width of male and female characters is evident. The neck is visible but, at this height, only a small portion of it is typically viewed.

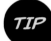

TIP

PAY PARTICULAR ATTENTION WHEN DRAWING THE JOINTS. FILL IN TENDONS AT THE BACK OF THE KNEES.

View from below

When the limbs are longer, the overall balance of the figure changes considerably when viewed from either below and above. With the view from below, focus especially on how the knees are depicted.

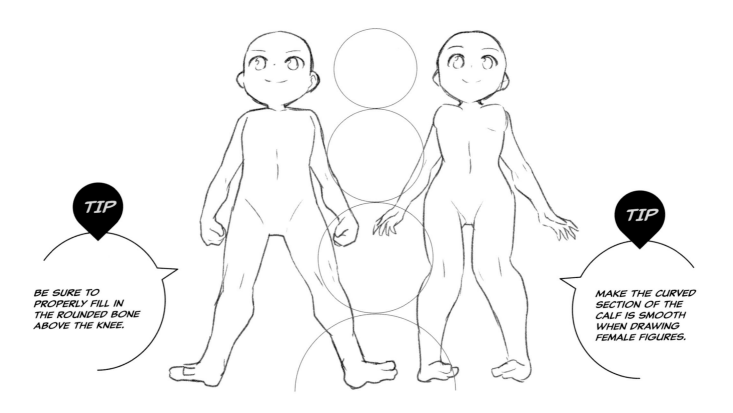

TIP

BE SURE TO PROPERLY FILL IN THE ROUNDED BONE ABOVE THE KNEE.

TIP

MAKE THE CURVED SECTION OF THE CALF IS SMOOTH WHEN DRAWING FEMALE FIGURES.

Bird's-eye view

When drawing the figure viewed from above, make the circles for the blocking-in smaller the closer you get to the feet. Follow the guide and fill in the figure.

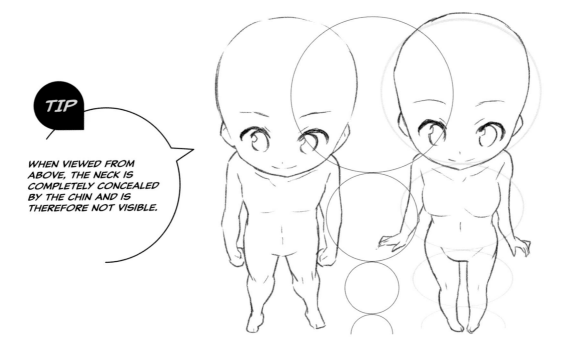

TIP

WHEN VIEWED FROM ABOVE, THE NECK IS COMPLETELY CONCEALED BY THE CHIN AND IS THEREFORE NOT VISIBLE.

EXPRESSION IN FIGURES 3.5 HEADS TALL

As the head-to-body ratio increases, it seems at first glance that the figures adhere less and less to the chibi style. But as you pose the figures, you'll discover the various ways chibi elements can still be incorporated.

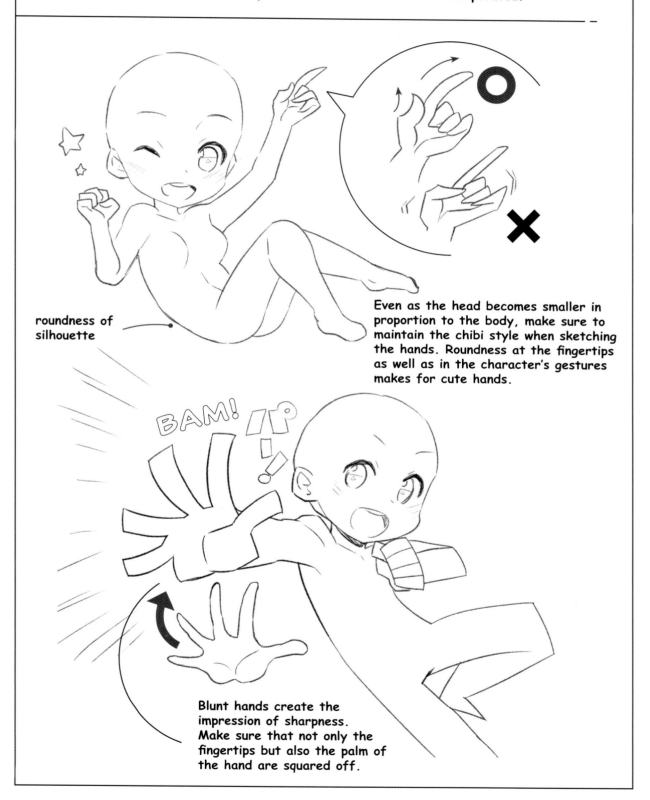

roundness of silhouette

Even as the head becomes smaller in proportion to the body, make sure to maintain the chibi style when sketching the hands. Roundness at the fingertips as well as in the character's gestures makes for cute hands.

BAM!

Blunt hands create the impression of sharpness. Make sure that not only the fingertips but also the palm of the hand are squared off.

PROPORTIONS FOR FIGURES 4 HEADS TALL

THIS IS THE LOWEST HEAD-TO-BODY RATIO FEATURED HERE. THESE PROPORTIONS ARE EASY TO WORK WITH TO DISTINGUISH MALES FROM FEMALES AS WELL AS TO DIFFERENTIATE YOUR CHARACTERS IN GENERAL. THEY ALSO ALLOW FOR GREATER EMOTIONAL EXPRESSION, SO THEY'RE IDEAL FOR A VARIETY OF SITUATIONS.

Front view

These proportions make it easier to express gender, age and personality while still allowing the adorable qualities of the chibi style to shine through.

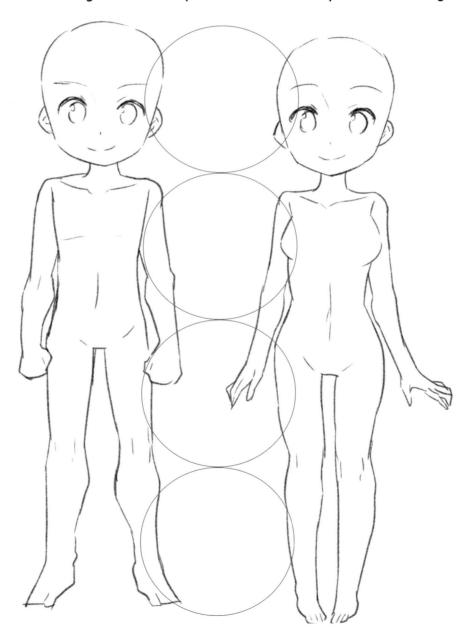

The proportions for the limbs and other body parts are the same as those for figures six to eight heads tall, making them easier to draw. Make sure to sketch in the curves at the waist when creating female characters.

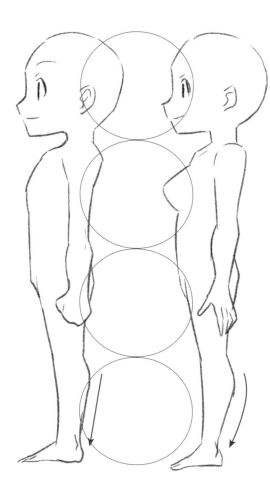

The amount of information in the drawing increases, with detailed dimension in the limbs and the line of the joints. For figures of these proportions, it will look odd if the line of the limbs is simplified.

TIP

THE FULLNESS OF THE CALVES AND THE THICKNESS OF THE ANKLES CAN ALSO BE USED TO INDICATE GENDER.

Rear view

Fill in a line down the center of the back to show the figure's spine. Draw in the shoulder blades too.

TIP

MAKE THE LINES OF THE BODY LOOK REALISTIC BY DRAWING IN THE TOP OF THE SHOULDER BLADES FOR MALES AND THE OUTLINE OF THE BUTTOCKS FOR FEMALES.

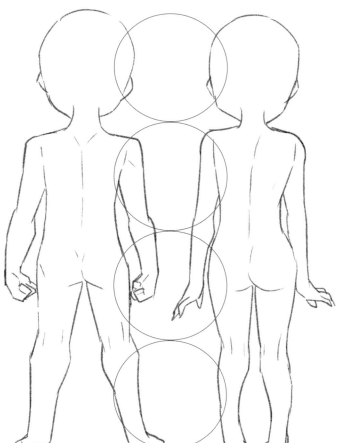

View from below

A characteristic of figures with these proportions is that the body appears the most stretched when viewed from below. Give the area below the knees a more angular, dynamic look.

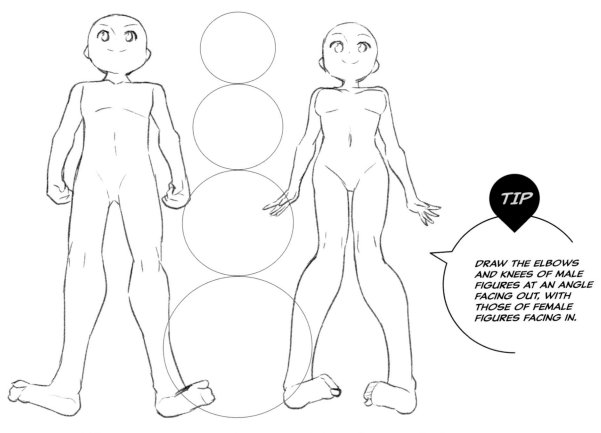

TIP

DRAW THE ELBOWS AND KNEES OF MALE FIGURES AT AN ANGLE FACING OUT, WITH THOSE OF FEMALE FIGURES FACING IN.

Bird's-eye view

When drawing a figure viewed from above, emphasize the chest and draw in the collarbone. Depending on the physique, you can give female figures sizable breasts.

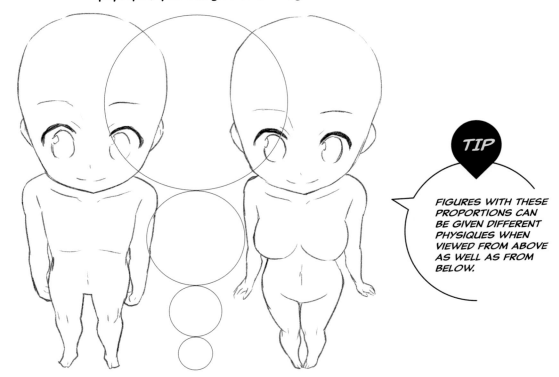

TIP

FIGURES WITH THESE PROPORTIONS CAN BE GIVEN DIFFERENT PHYSIQUES WHEN VIEWED FROM ABOVE AS WELL AS FROM BELOW.

Side view

The 1:4 head-to-body ratio offers more potential to create differences in facial profiles according to your personal style. Draw the nose, chin, mouth and facial outline carefully to expand the range of expression.

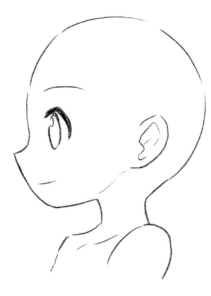

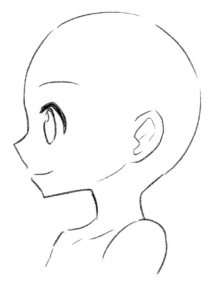

The basic facial profile. The mouth is positioned within the outline of the face. A rounded chin creates the cute look particular to the chibi style.

The mouth placed to meet the outline of the face. Creating a mouth like this on the original profile results in a slack-looking face, so sharpen the line along the bridge of the nose and down around the chin.

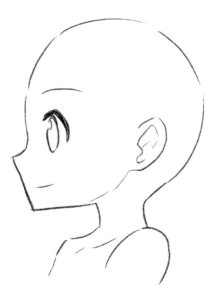

Here, the chin protrudes, creating a cuteness that's cool at the same time. This kind of profile suits a male who is a main character or a dreaded rival.

Clearly drawing in the nose and mouth makes for a classy look. However, the style of the drawing needs to be considered, as highly defined features don't always work.

DRAWING VARIOUS BODY SHAPES

IT'S NOT JUST THE FACE BUT ALSO THE SHAPE OF THE BODY THAT'S AN IMPORTANT ELEMENT IN MAKING YOUR CHARACTERS UNIQUE. HERE, WE ANALYZE THE DIFFERENCES BETWEEN VARIOUS TYPES OF BODIES—SUCH AS STOCKY, THIN AND MUSCULAR—FOR FIGURES TWO AND FOUR HEADS TALL.

Stocky

Add bulk and plumpness to the entire figure, while being aware that the joints become less defined due to the increased size. The face is completely round. Shortening the legs gives the figure a placid look.

When creating a bulkier or stockier version of a figure four heads tall, expand the blocking-in section for each body part.

For a figure two heads tall, create a clearly protruding stomach.

Thin

Create a figure with little fat and bones protruding to contrast with that of a stocky character. Make the hands, feet and joints angular so they'll stand out more. Draw the face as a long, oval shape when emphasizing its gaunt or fleshy qualities.

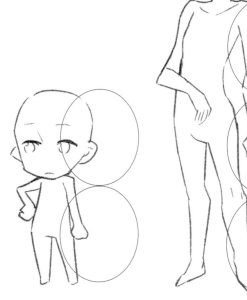

Muscular

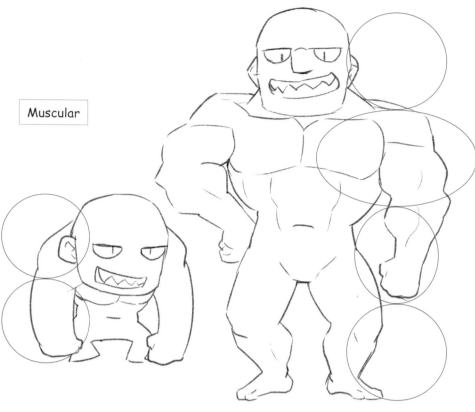

Emphasize strength and musculature for this type of character. There's no excess fat around the joints of a muscular figure. Emphasizing those specific areas creates the impression of a musclebound physique, while a square face with a large chin adds to the sense of sturdiness.

Svelte

Sex appeal is associated with voluptuousness, so make the breasts, buttocks and other curves fuller than they would be on a basic female body. The eyes have a flirtatious look, while it's also important to get the sinuous pose just right.

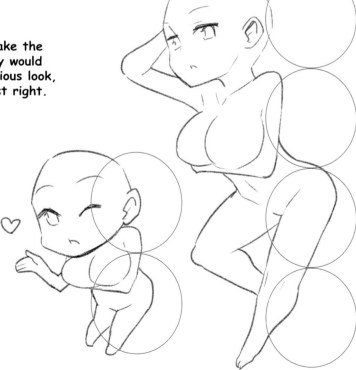

DRAWING DIFFERENT HAIRSTYLES

HAIR IS AN IMPORTANT ELEMENT IN MAKING YOUR CHARACTERS MEMORABLY YOUR OWN. IN MANGA TARGETING YOUNG GIRLS, MANY OF THE CHARACTERS ARE IDENTIFIED BY THEIR HAIRSTYLES. HERE, WE LOOK AT THE TYPICAL DRAWING METHODS.

Male characters' hairstyles

This is a relatively unstyled look that suits main characters with serious or timid dispositions. Depending on the clothing, these looser locks can also make for an urbane look.

Basic spiked hair, drawn with the bangs swept straight up. A good choice for highlighting the vibe of an edgier or more transgressive character.

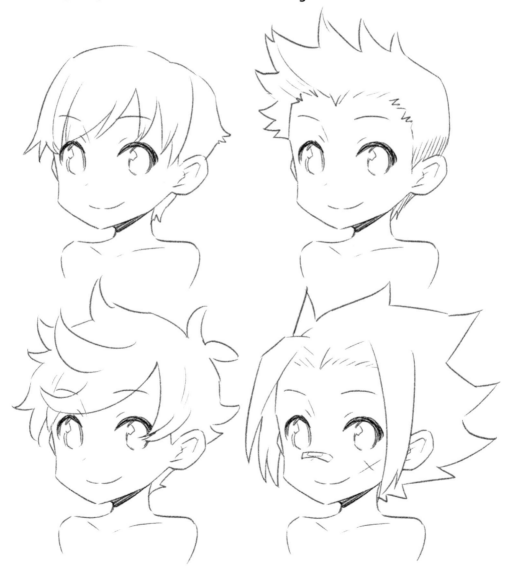

The messy tresses of the bedhead look. It's recommended for a character who follows fashion trends, has special abilities or is somewhat whimsical.

This style suits a hot-blooded or passionate character. Emphasize the spikes of the bangs and hair at the back. If there are wounds or bandages adding accents to the face, apply the chibi style even to those details.

Female characters' hairstyles

This is a look that's casual or not overstyled. Keep in mind the sense of smooth shininess as you draw. Give the hair shaggy layers for a light look, or draw it gathered into strips to create more weight.

Emphasize the undulations in this wavy style to make it reflect chibi style. Protruding wisps at the top of the head finish off the look.

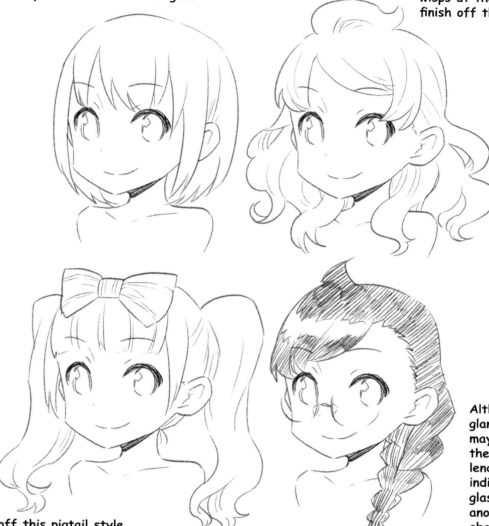

A bow tops off this pigtail style. The trick to getting this look right is making the individual parts of the drawing large. Create variation by altering the volume and length of the hair.

Although at first glance this braid may seem plain, the chibi treatment lends it a wonderfully individual style. Add glasses, freckles or another distinguishing characteristic for a cute look.

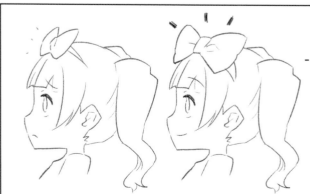

Give hair accessories the chibi treatment too!

Make bows and other distinguishing elements large to highlight a character's individuality. If a bow or similar element is hard to see because of the angle, alter it so that it faces slightly more toward the front.

FACIAL DIFFERENCES DUE TO AGE

WHILE CHIBI CHARACTERS TEND TO APPEAR YOUNG, IT'S IMPORTANT TO BE ABLE TO DISTINGUISH BETWEEN ADULTS AND CHILDREN.

Adults When drawing adults, try to express the refinement and confidence that can come with age.

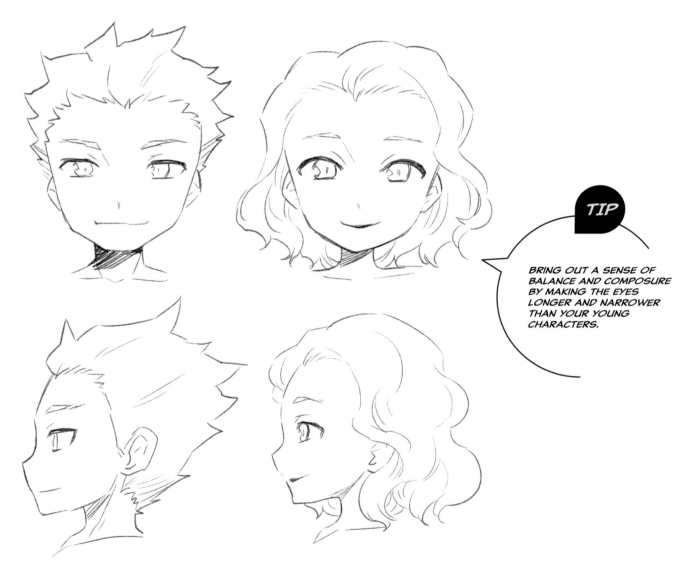

TIP

BRING OUT A SENSE OF BALANCE AND COMPOSURE BY MAKING THE EYES LONGER AND NARROWER THAN YOUR YOUNG CHARACTERS.

When drawing adult men, position the eyes higher than for boys and make the lines of the face more angular. In profile, the bridge of the nose should be clearly defined.

For women, make the position of the eyes slightly higher than on girls. Adding fullness to the lips creates an adult appearance.

Small children · Make the eyes larger and the forehead broader than usual to emphasize a juvenile appearance.

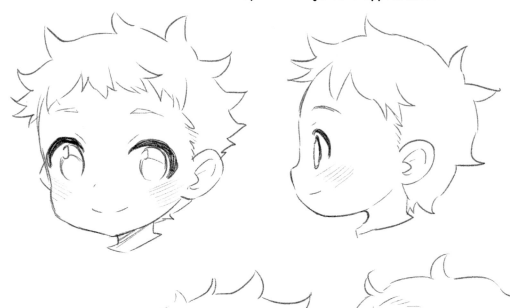

Babies

Emphasize the broadness of the forehead even more so than on toddlers. Giving the eyebrows and hair a soft, wispy look is also key.

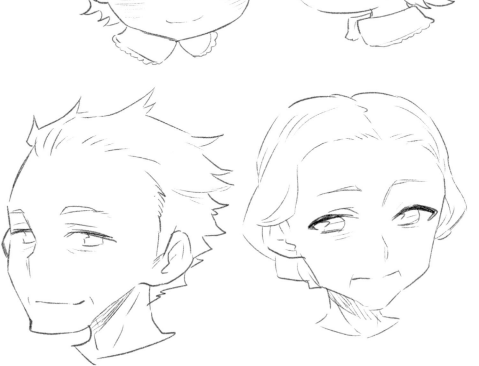

Old men and women · Add wrinkles caused by skin sagging around bony facial features. Draw lines around the eyelids and draw the eyes so that they're not fully open.

CAT EARS & RABBIT EARS

RATHER THAN JUST PUTTING EARS ON A CHARACTER, MAKE SURE THEY FIT WITH THE HEAD AND HAIR AND USE CHIBI TECHNIQUES TO BRING OUT THE INDIVIDUALITY.

Add cat ears to a spirited or somewhat wild character. Make them pointy to create an energetic look.

Use your choice of ears to distinguish your characters: a rabbit-eared person might tend to be a bit lonely and quiet, for example.

Recently, more male characters with cat ears have been appearing. Add expression to the ears, such as having one angled down, to bring out the character's unique qualities.

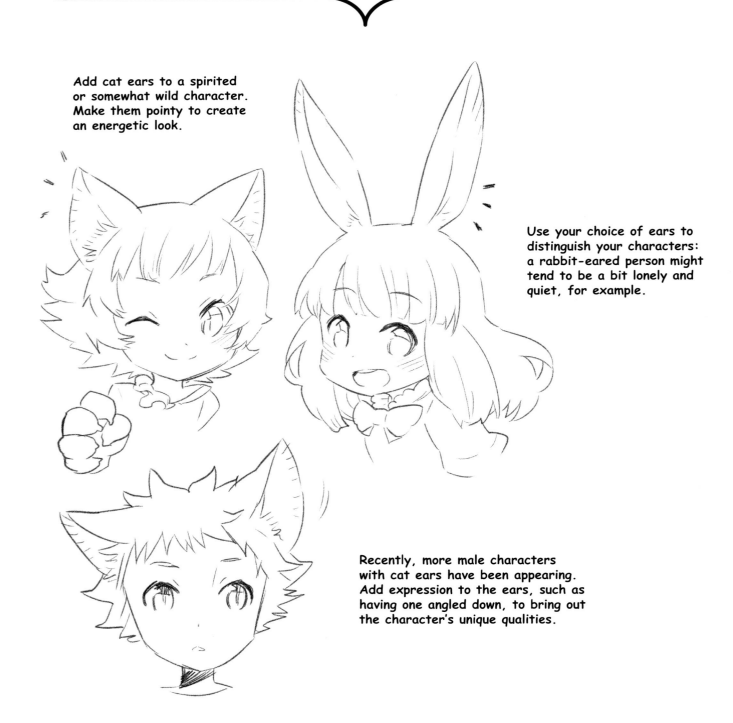

CHIBI EXPRESSIONS

JOY

CHIBI CHARACTERS ARE TYPICALLY BURSTING AT THE SEAMS WITH HAPPINESS, SO YOU'LL WANT TO MASTER A RANGE OF JOYFUL EXPRESSIONS. IF YOU CONSIDER HOW YOU'LL BREAK DOWN EACH CHARACTER'S EXPRESSION BEFORE YOU START DRAWING, IT'LL MAKE THE DRAWING PROCESSES THAT FOLLOW MUCH SIMPLER.

Mild joy

Lifting the corners of the mouth a little creates an expression of mild joy. Draw the eyebrows in a gentle curve so that they point downward and enhance the overall sense of pleasure forming on the face.

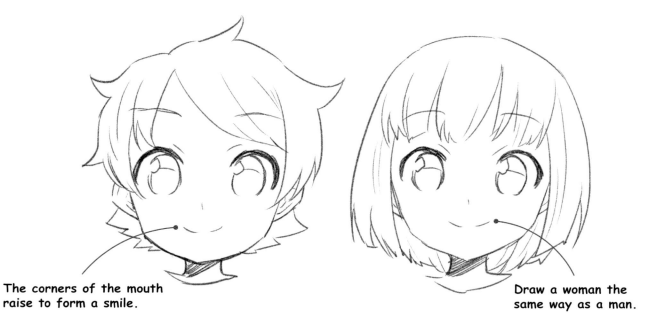

The corners of the mouth raise to form a smile.

Draw a woman the same way as a man.

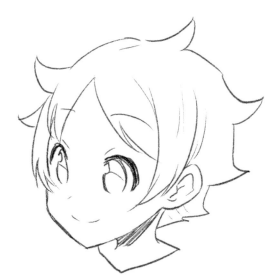

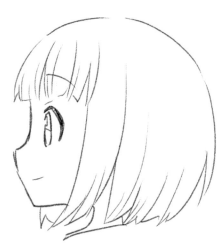

Draw the corner of the mouth longer on the side of the face that's opposite to the direction it's pointing.

On a face completely in profile, the mouth won't look strange if it's drawn some distance from the facial outline.

Extreme happiness

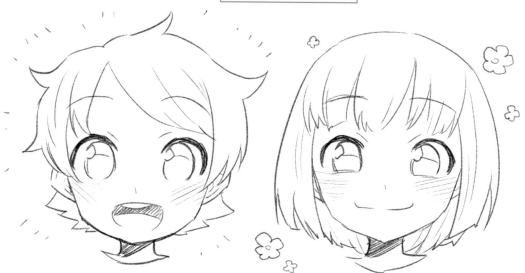

Indicate extreme happiness with an open mouth. Draw the lower part of the mouth down to the chin faintly, as if it were naturally disappearing. Making the front teeth slightly visible adds that extra touch of cuteness.

A broad smile causes the mouth to stretch and lift on both sides. Beyond the mouth, pay attention to the slight narrowing of the eyes. Adding flowers to the background enhances the look.

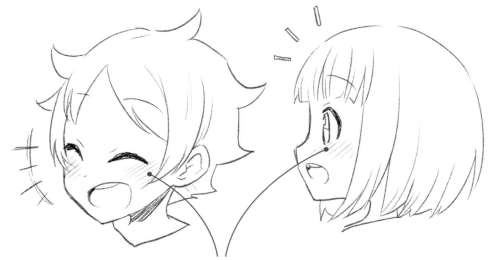

Laughter makes the eyes close. Drawing effect lines near the face works well too, and diagonal lines on the cheeks suggest the flush of shyness or embarrassment.

When drawing the face in profile, it's easier to locate the mouth within the facial outline. Three fine lines evoke the look of happy realization.

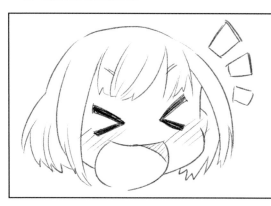

Make facial features large

Drawing facial features so large that they extend beyond the facial outline makes it easy to communicate emotions in the chibi style. Don't take things so far that the character becomes no longer recognizable, but this kind of exaggerated expression certainly makes it easy to convey your character's emotion.

ANGER

CAPTURING THE CHANGES IN THE SHAPE OF THE EYEBROWS AND THE MOUTH IS THE KEY TO DEPICTING ANGRY FACES. ADDING BODY MOVEMENT AND HAND GESTURES MAKES IT EVEN EASIER TO CONVEY A CHARACTER'S IRE.

Slight irritation

The eyebrows are the feature that changes the most. It's common for strong-willed characters' eyebrows to rise, while weak characters lower their eyebrows. The mouth resembles an inverted V.

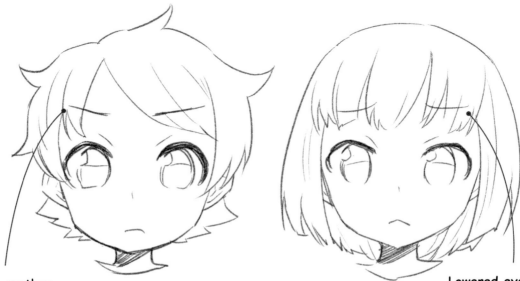

When sensing another character's anger, the eyebrows rise.

Lowered eyebrows convey a sense of worry as well as annoyance.

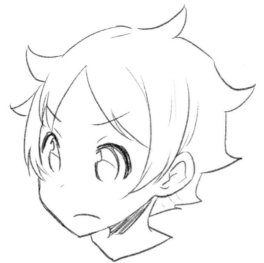

Setting the mouth on a diagonal angle creates an angry look.

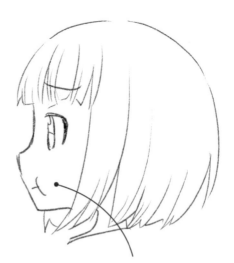

Puffed-out cheeks often accompany a sulking face.

Extremely angry or irritated

Draw the eyebrows and eyes in a caricaturized style, adding in symbols and effects around the face. This is key to achieving the chibi look.

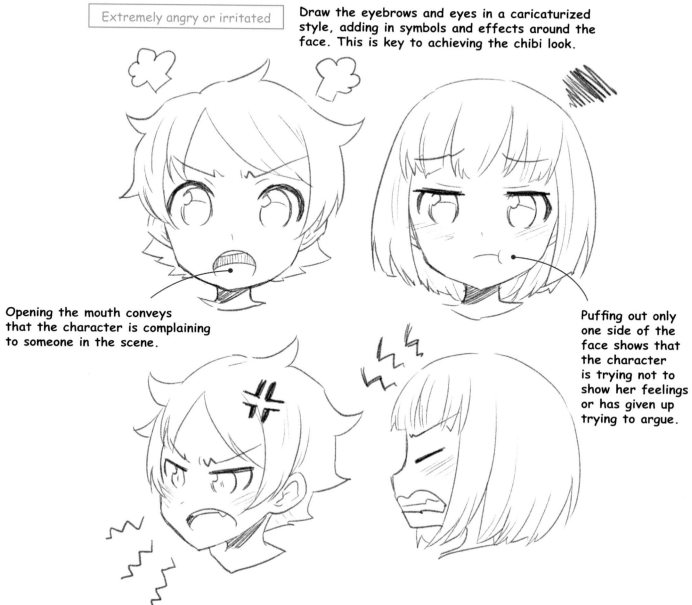

Opening the mouth conveys that the character is complaining to someone in the scene.

Puffing out only one side of the face shows that the character is trying not to show her feelings or has given up trying to argue.

Here, the character's saying something in anger. Zigzag lines emerging from the mouth emphasize the sense of complaint. Draw the vein popping on the forehead too.

An expression used to depict irrepressible irritation. Zigzag lines emerge from the head, and the eyebrows are considerably raised. Increased wrinkles between the brows finish off the effect.

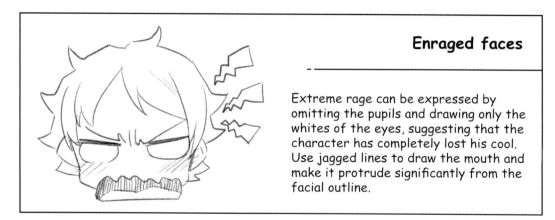

Enraged faces

Extreme rage can be expressed by omitting the pupils and drawing only the whites of the eyes, suggesting that the character has completely lost his cool. Use jagged lines to draw the mouth and make it protrude significantly from the facial outline.

SADNESS

TEARS CERTAINLY SIGNAL SADNESS, BUT THERE ARE OTHER WAYS TO EXPRESSING CHARACTERS WITH THE BLUES. SIMPLY CHANGING THE WAY THE EYEBROWS ARE DRAWN ALTERS THE IMPRESSION. TEARS CAN CAPTURE VARYING DEGREES AND MODES OF SADNESS DEPENDING ON HOW THEY'RE DRAWN.

Depressed

Brows in an inverted arch shape yield a troubled look; a small, slack mouth adds to the effect. Lines above the eyelids make for a dejected appearance.

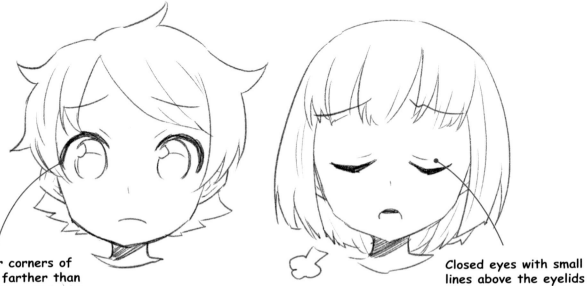

Bring the outer corners of the eyes down farther than usual to make them look lower, creating the impression of being ill at ease.

Closed eyes with small lines above the eyelids create the sense of being disheartened.

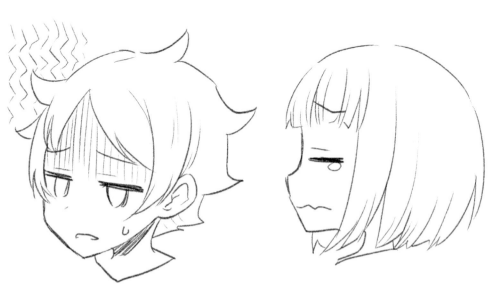

The lack of highlights in the pupils strikes a downhearted mood. Shadows that suggest sluggishness make the character look even more depressed.

Zigzag lines for the mouth suggest an inability to express oneself or properly reply or a mounting irritation at things not going according to plan.

Crying

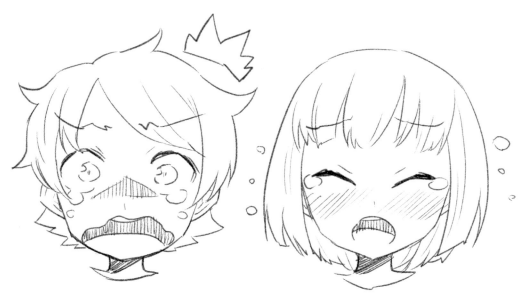

Draw tears so that they express a character's individuality. In addition to teardrops, draw lines that depict buckets of tears for comic effect.

Large teardrops falling all around the figure add impact. Diagonal lines on the face to indicate reddening give the crying character a cuter look.

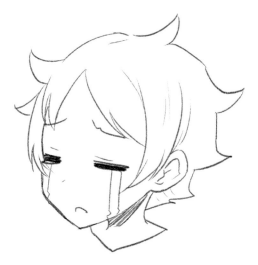

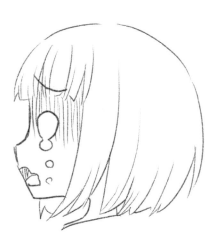

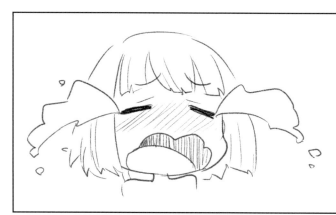

Cry me a river

When the character is crying uncontrollably, it's fine to go overboard with the tears. Omit the nose and use diagonal lines across the width of the face to indicate redness. Just be careful not to overdo things so much that the character becomes unrecognizable!

HAPPINESS

IN THIS SECTION, WE'LL LOOK AT HOW EMOTION IS EXPRESSED THROUGH THE BODY RATHER THAN THROUGH THE FACE ALONE. USE YOUR CHARACTER'S ENTIRE BODY TO EXPRESS JOY, SHOWING THE ARMS OPEN WIDE AND THE LEGS SPREAD APART, REMEMBERING THAT SOME MOVEMENTS ARE DIFFERENT FOR MALE AND FEMALE CHARACTERS.

Two heads tall

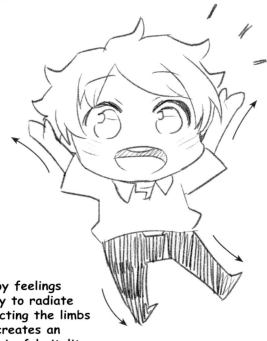

Think of happy feelings causing energy to radiate outward! Directing the limbs straight out creates an expression of joyful vitality.

Placing the feet together conveys quiet contentment. Raise the eyes and add a smile for an adorable expression.

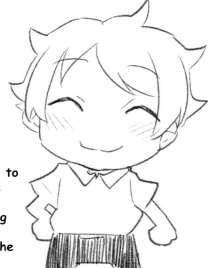

Adding diagonal lines to the cheeks gives the impression that the character is brimming or overflowing with happiness. Turn up the mouth into a smile.

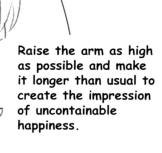

Raise the arm as high as possible and make it longer than usual to create the impression of uncontainable happiness.

Four heads tall

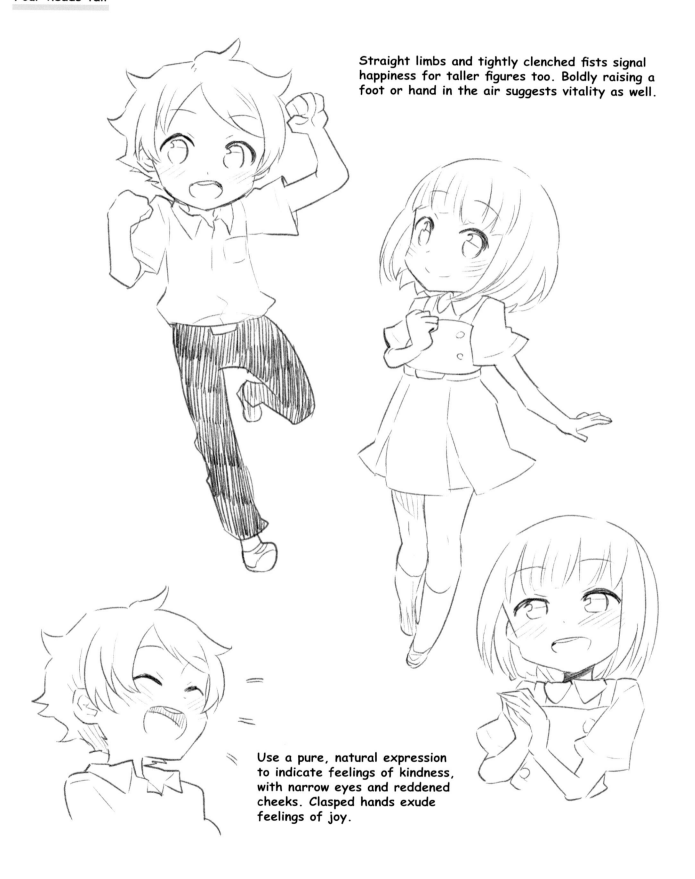

Straight limbs and tightly clenched fists signal happiness for taller figures too. Boldly raising a foot or hand in the air suggests vitality as well.

Use a pure, natural expression to indicate feelings of kindness, with narrow eyes and reddened cheeks. Clasped hands exude feelings of joy.

ELATION

ELATION IS PERHAPS THE EXPRESSION WITH THE GREATEST VARIETY WHEN DRAWING CHIBI CHARACTERS. WHEN USED ON CHARACTERS OF REGULAR PROPORTIONS, THESE EXPRESSIONS CONVEY HEIGHTENED EMOTION.

Two heads tall

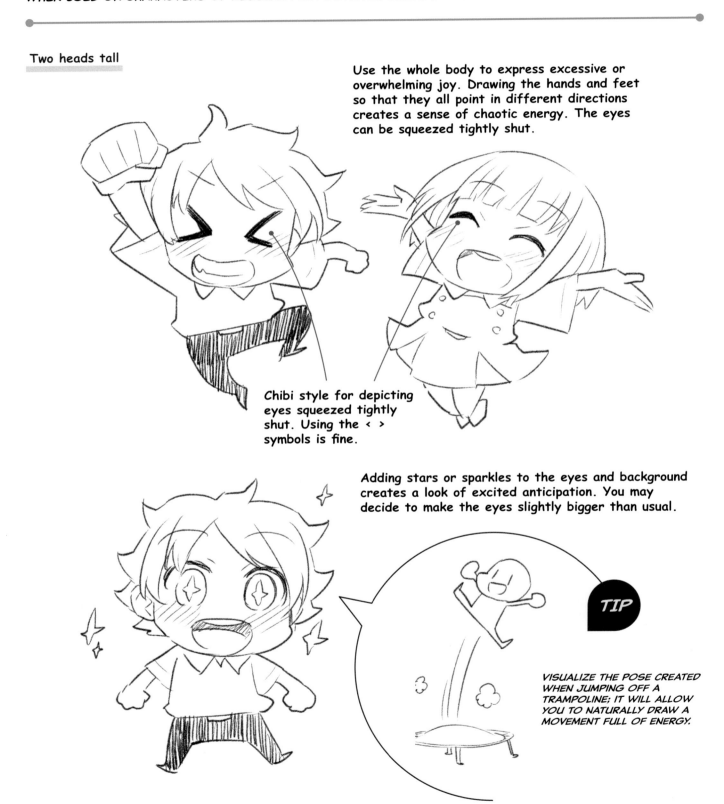

Use the whole body to express excessive or overwhelming joy. Drawing the hands and feet so that they all point in different directions creates a sense of chaotic energy. The eyes can be squeezed tightly shut.

Chibi style for depicting eyes squeezed tightly shut. Using the < > symbols is fine.

Adding stars or sparkles to the eyes and background creates a look of excited anticipation. You may decide to make the eyes slightly bigger than usual.

TIP

VISUALIZE THE POSE CREATED WHEN JUMPING OFF A TRAMPOLINE; IT WILL ALLOW YOU TO NATURALLY DRAW A MOVEMENT FULL OF ENERGY.

Four heads tall

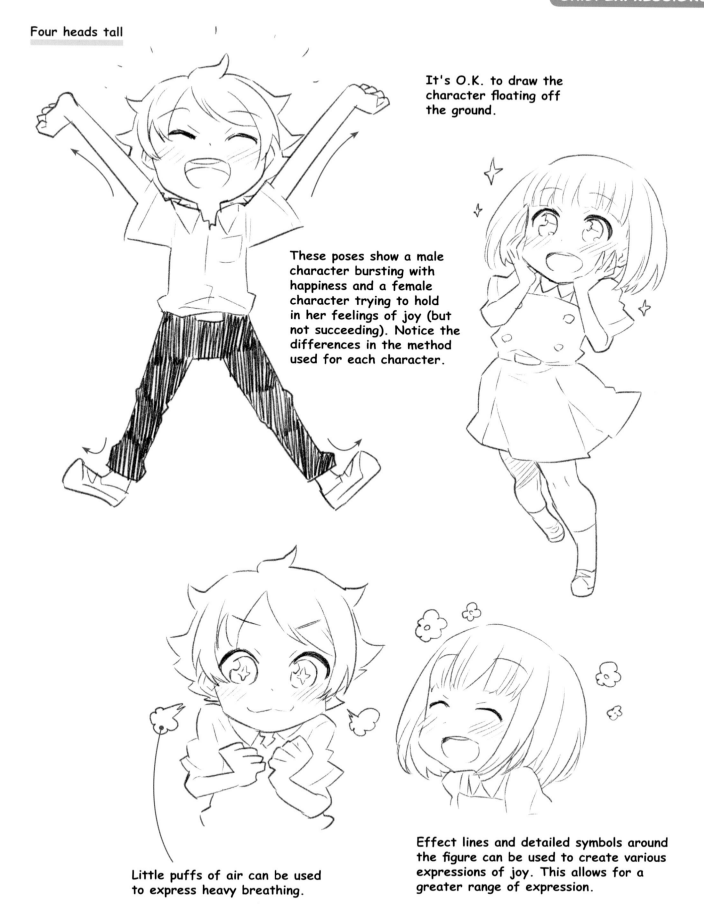

It's O.K. to draw the character floating off the ground.

These poses show a male character bursting with happiness and a female character trying to hold in her feelings of joy (but not succeeding). Notice the differences in the method used for each character.

Little puffs of air can be used to express heavy breathing.

Effect lines and detailed symbols around the figure can be used to create various expressions of joy. This allows for a greater range of expression.

RAGE

THESE EXPRESSIONS OF RAGE MAKE USE OF THE ENTIRE BODY. FOLDED ARMS INDICATE BOTTLED-UP ANGER, WHILE HANDS ON THE HIPS SHOW THAT THE CHARACTER IS DIRECTING RAGE AT SOMEONE ELSE. OTHER MOVEMENTS SUCH AS WAVING OR FLAILING THE ARMS IN THE AIR ARE ALSO TYPICAL OF CHIBI CHARACTERS.

Two heads tall

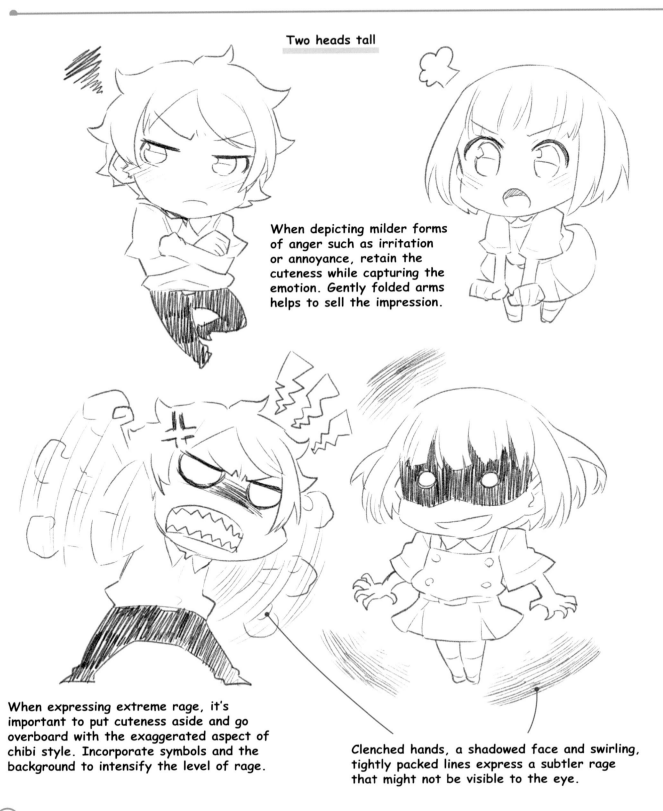

When depicting milder forms of anger such as irritation or annoyance, retain the cuteness while capturing the emotion. Gently folded arms helps to sell the impression.

When expressing extreme rage, it's important to put cuteness aside and go overboard with the exaggerated aspect of chibi style. Incorporate symbols and the background to intensify the level of rage.

Clenched hands, a shadowed face and swirling, tightly packed lines express a subtler rage that might not be visible to the eye.

Four heads tall

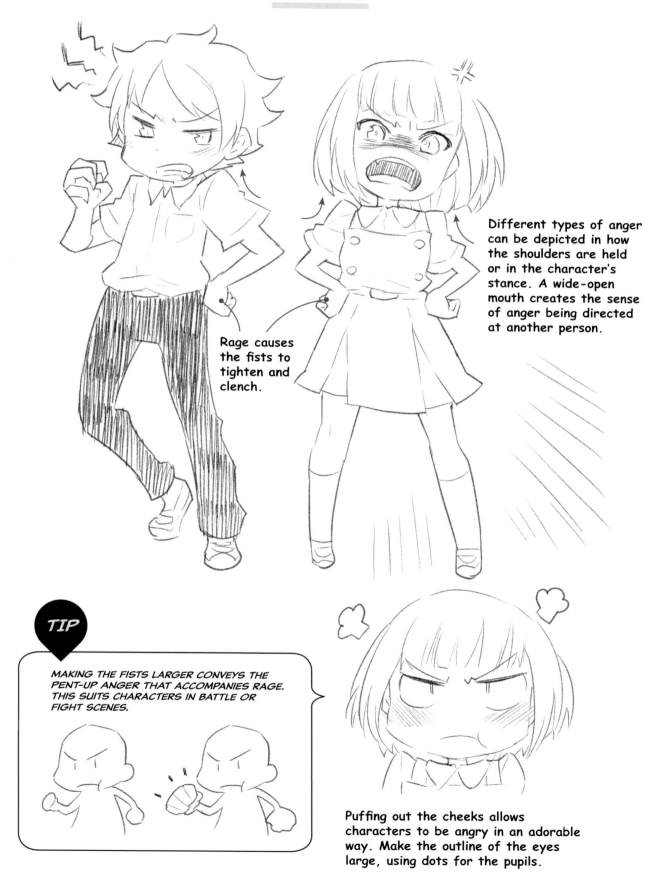

Rage causes the fists to tighten and clench.

Different types of anger can be depicted in how the shoulders are held or in the character's stance. A wide-open mouth creates the sense of anger being directed at another person.

TIP

MAKING THE FISTS LARGER CONVEYS THE PENT-UP ANGER THAT ACCOMPANIES RAGE. THIS SUITS CHARACTERS IN BATTLE OR FIGHT SCENES.

Puffing out the cheeks allows characters to be angry in an adorable way. Make the outline of the eyes large, using dots for the pupils.

DESPAIR

WHAT HAPPENS WHEN SADNESS IS EXPRESSED WITH THE WHOLE BODY? IT DEPENDS ON THE DEGREE OF DEFEAT OR DEVASTATION YOUR CHARACTER FEELS: TEAR-FILLED, SUNKEN DEJECTION OR STUNNED SILENCE. USE THIS RANGE OF EXPRESSIONS TO REFER TO SO YOU CAN RENDER IT RIGHT.

Two heads tall

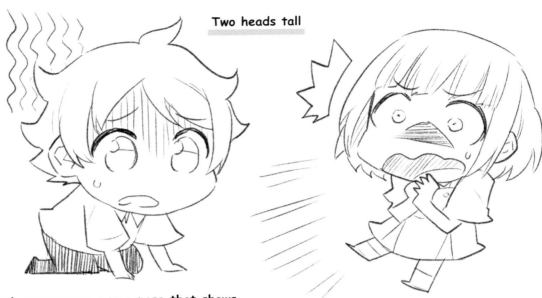

For a downcast appearance, use a pose that shows a lack of energy, with the character sinking to the floor. Weak wavy lines heighten the effect.

When receiving a shock, the character's body goes stiff, momentarily immobile from the sense of alarm. Shrinking the pupils adds to the expression of shock in the eyes.

Introduce lines to the background to emphasize feelings of depression.

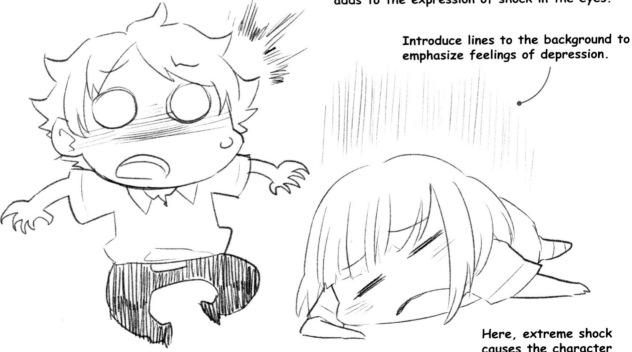

This method involves making the eyes large and omitting the pupils, expressing shock so great that the soul seems to have left the body. Making the mouth off-kilter intensifies the effect.

Here, extreme shock causes the character to crumple to the floor.

Four heads tall

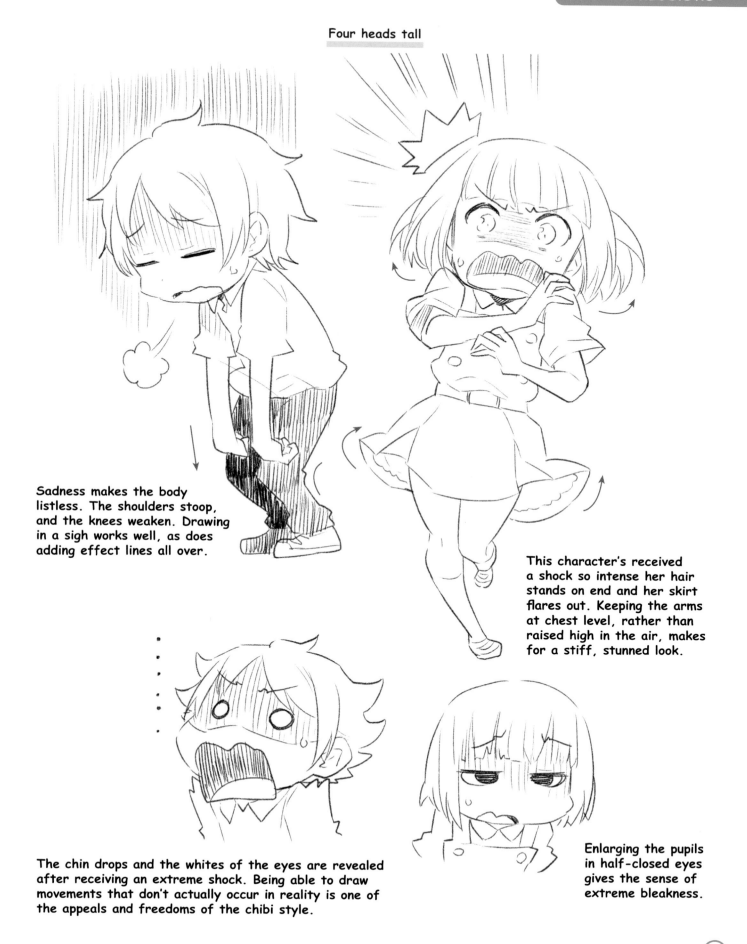

Sadness makes the body listless. The shoulders stoop, and the knees weaken. Drawing in a sigh works well, as does adding effect lines all over.

This character's received a shock so intense her hair stands on end and her skirt flares out. Keeping the arms at chest level, rather than raised high in the air, makes for a stiff, stunned look.

The chin drops and the whites of the eyes are revealed after receiving an extreme shock. Being able to draw movements that don't actually occur in reality is one of the appeals and freedoms of the chibi style.

Enlarging the pupils in half-closed eyes gives the sense of extreme bleakness.

IN TEARS

THERE ARE VARIOUS TYPES OF TEARS, TOO, SUCH AS TEARS OF REGRET, JOY OR IRREPRESSIBLE SADNESS. USE MOVEMENT IN THE ENTIRE BODY TO PORTRAY THE ANGUISH AND LEND NUANCE TO THE TEARS.

Two heads tall

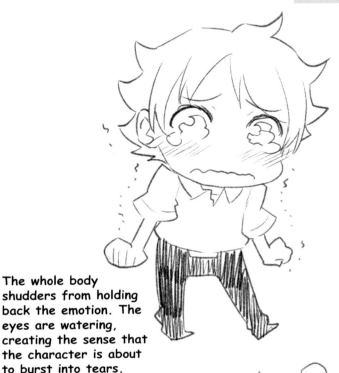

The whole body shudders from holding back the emotion. The eyes are watering, creating the sense that the character is about to burst into tears.

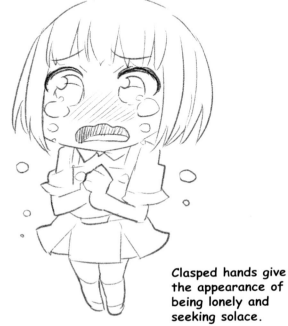

Clasped hands give the appearance of being lonely and seeking solace.

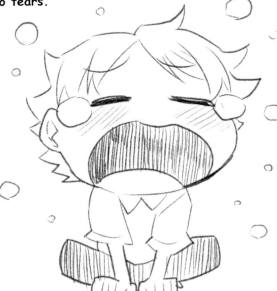

Scattering tears around the character sets the scene for an uncontrollable crying jag. Draw the mouth wide open as if wailing.

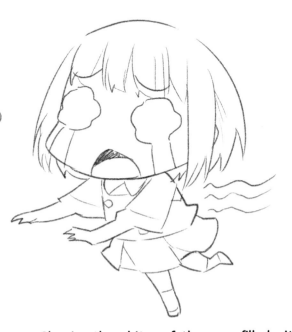

Showing the whites of the eyes filled with tears is one chibi method of suggesting that the character is at her wit's end.

Four heads tall

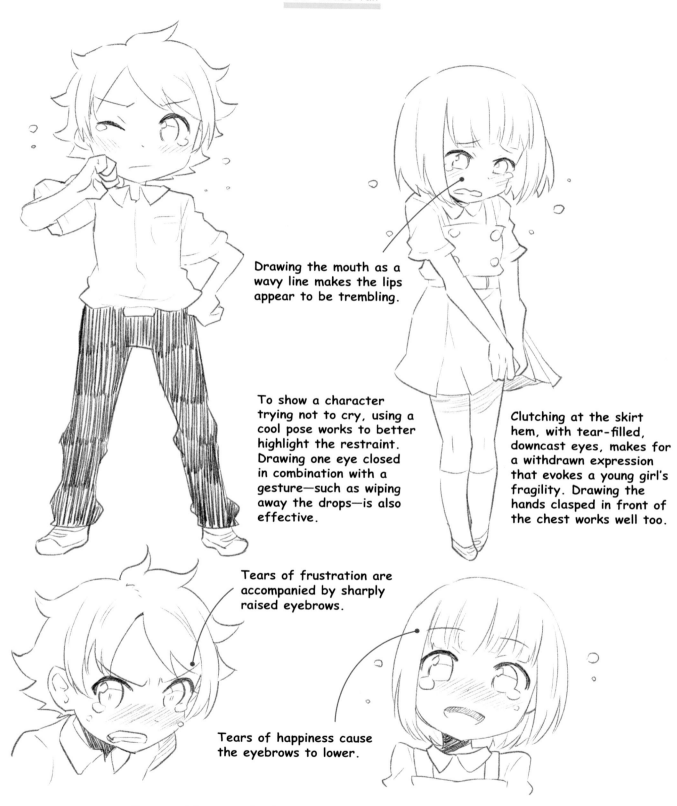

Drawing the mouth as a wavy line makes the lips appear to be trembling.

To show a character trying not to cry, using a cool pose works to better highlight the restraint. Drawing one eye closed in combination with a gesture—such as wiping away the drops—is also effective.

Clutching at the skirt hem, with tear-filled, downcast eyes, makes for a withdrawn expression that evokes a young girl's fragility. Drawing the hands clasped in front of the chest works well too.

Tears of frustration are accompanied by sharply raised eyebrows.

Tears of happiness cause the eyebrows to lower.

Rage and joy can also bring on tears. They're not just for sad situations—used effectively tears can be applied to a range of scenarios and expressions.

OTHER EMOTIONS

JOY, SADNESS AND RAGE ARE JUST A FEW OF THE BASIC EMOTIONS YOU'LL NEED TO CAPTURE. HERE ARE A FEW MORE TO ADD TO YOUR REPERTOIRE.

Two heads tall

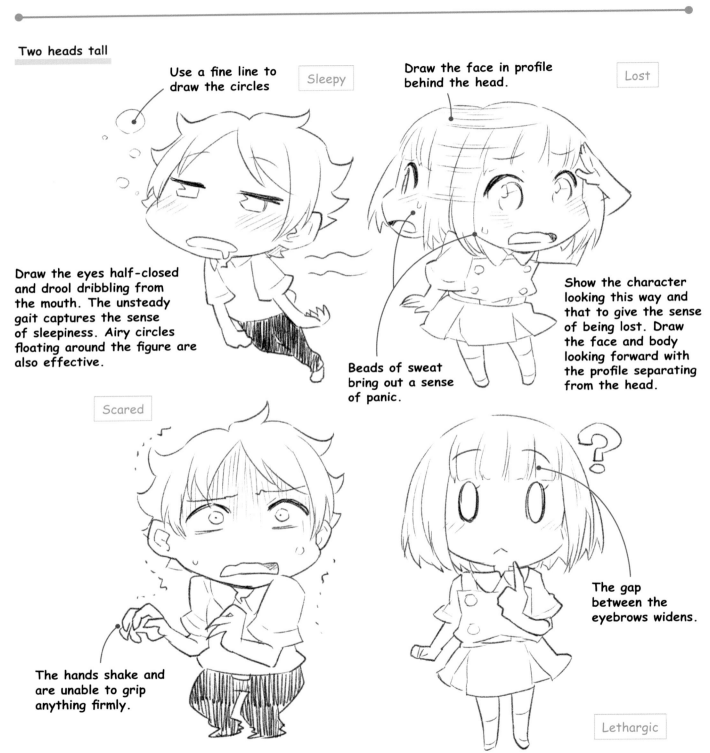

Use a fine line to draw the circles

Sleepy

Draw the face in profile behind the head.

Lost

Draw the eyes half-closed and drool dribbling from the mouth. The unsteady gait captures the sense of sleepiness. Airy circles floating around the figure are also effective.

Beads of sweat bring out a sense of panic.

Show the character looking this way and that to give the sense of being lost. Draw the face and body looking forward with the profile separating from the head.

Scared

The hands shake and are unable to grip anything firmly.

The gap between the eyebrows widens.

Lethargic

When your character's frightened by something he's seen or is confronted a scary situation, draw fine wavy lines around the figure to convey fear.

Making the eyes completely white expresses blankness or the inability to recall something. Question marks can also be added in.

Four heads tall

Sorrowful

The lowered brows and lowered corners of the mouth make this expression similar to that of sadness.

Adding an element such as falling petals suggests a fleeting moment, evoking an even more bittersweet air.

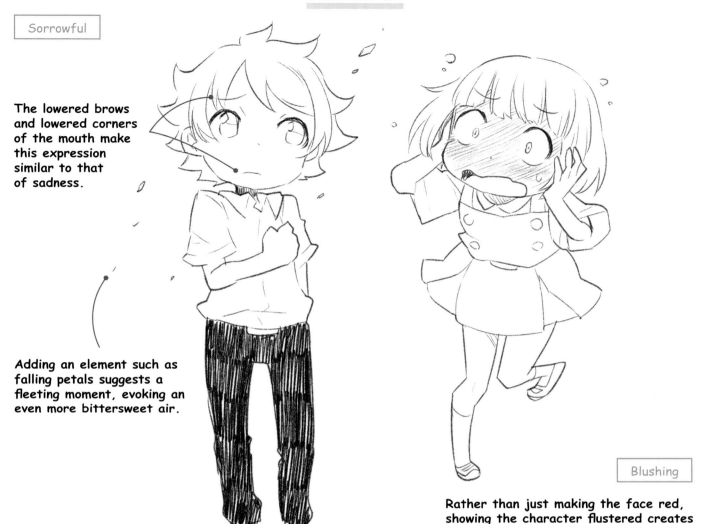

Blushing

Rather than just making the face red, showing the character flustered creates a more realistic look. The hands on the cheeks are adorably pathetic.

The hand is clenched on the chest, trying to keep the emotion in check. The facial expression should be vague, rather than too composed, for a look that conveys the passion of youth.

Not a thought in their heads

Drawing only vertical bars for the eyes is an element of the chibi style that allows for a face that's generically cute but shows no other details or nuances. This makes it hard to assign any emotion to your character's face, but this can be used to advantage. This simplified expression is often used as a way to show that the character is not thinking about anything at all.

EXPRESSING EMOTION IN ROBOTS AND MASKED FIGURES

APPLYING CHIBI STYLE, EVEN MECHANICAL CHARACTERS OR THOSE WITH VEILED VISAGES CAN SHOW EMOTION.

Even if characters aren't exactly human, you can capture and portray their feelings through the deft use of movement. In the case of a robot without facial features, it's fine to just add them in.

For a masked figure, move parts of the mask that wouldn't actually move in reality. Adding bold expression allows you to build the character's personality, so take full advantage here of the chibi style!

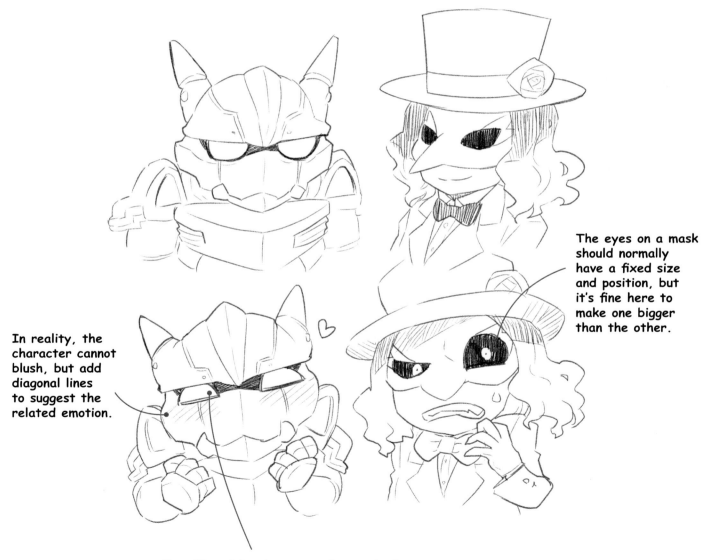

The eyes on a mask should normally have a fixed size and position, but it's fine here to make one bigger than the other.

In reality, the character cannot blush, but add diagonal lines to suggest the related emotion.

Just like with a human, make a robot's eyes narrower to express joy.

Lesson 3

CHIBI IN MOTION

WALKING

NOW IT'S TIME TO MAKE YOUR CHARACTERS MOVE, STARTING WITH THE MOST BASIC: WALKING. IT MAY SOUND SIMPLE, BUT BECAUSE THERE'S NOT MUCH MOTION INVOLVED, IT'S HARD TO CAPTURE WALKING SO THAT IT APPEARS NATURAL.

Two heads tall

From a regular, everyday scene to those with specific locations and situations, this is a basic movement that's used in all kinds of illustrations.

Draw the character so that when the right leg is extended, the left hand is also; when the left leg is extended, so is the right hand. Keeping the hair neat and unruffled helps create the appearance of walking.

TIP

FOR A FAST-PACED OR ENERGETIC WALK, BEND THE ELBOWS AND DRAW THE LEGS SO THAT THEY'RE EXTENDED AND FLOATING A LITTLE ABOVE THE GROUND. A SMILING FACE ADDS TO THE LOOK.

It's a bit difficult to capture a walking figure from the front. Alter the size of the hands and feet to bring out a sense of depth.

Four heads tall A long stride makes for an energetic pose, while small steps match a shy appearance. Draw the stride to suit the character's personality and apply the chibi technique to the walk as well.

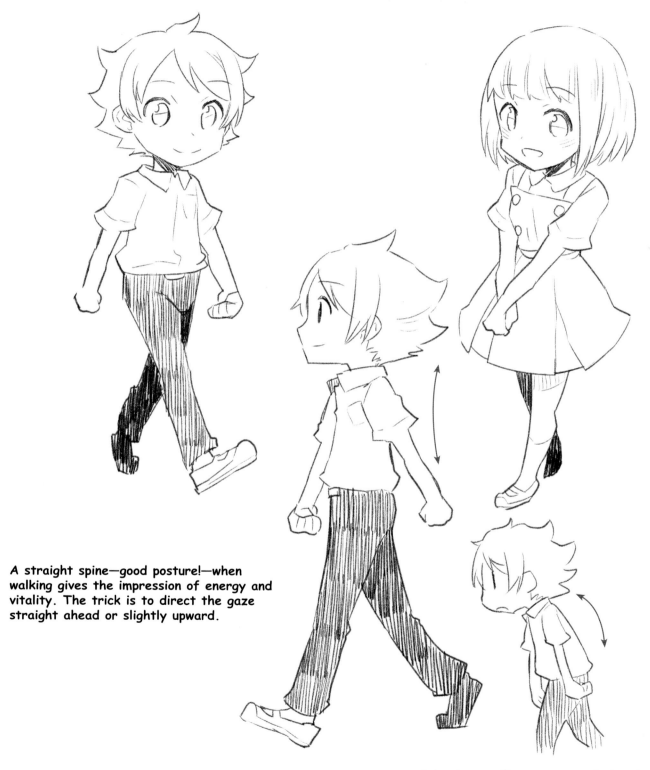

A straight spine—good posture!—when walking gives the impression of energy and vitality. The trick is to direct the gaze straight ahead or slightly upward.

A bent-over figure appears to be drained of energy. Decreasing the range of motion in the arms evokes this lack of drive.

RUNNING

AS WITH WALKING, RUNNING HAS A WIDE VARIETY OF MODES AND USES, FROM EVERYDAY SCENES TO DRAMATIC SITUATIONS. USING THE CHIBI TECHNIQUE EFFECTIVELY TO DEPICT RUNNING LENDS REALISM TO A SCENE.

<u>Two heads tall</u> Pay attention to the posture and movement of the body when drawing a running figure, even more so than walking. Adding details to nuance to a character's running style allows you to highlight the personality and emotions.

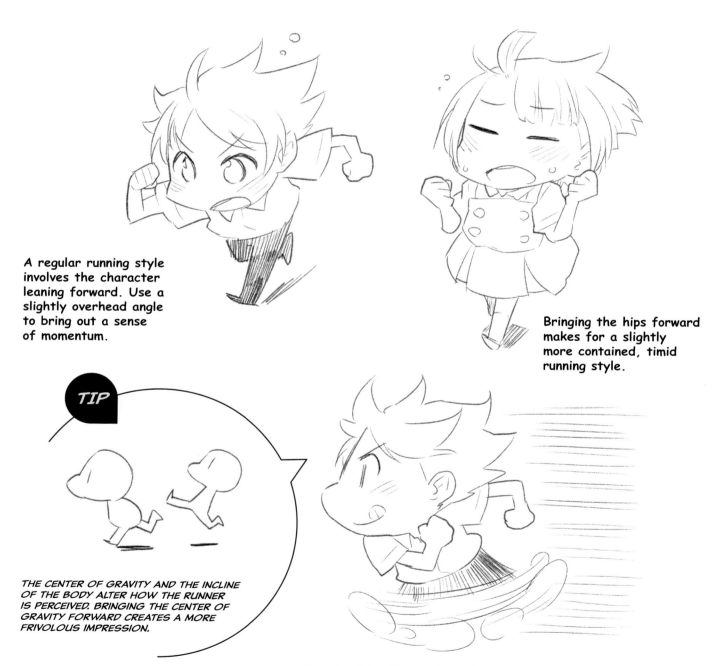

A regular running style involves the character leaning forward. Use a slightly overhead angle to bring out a sense of momentum.

Bringing the hips forward makes for a slightly more contained, timid running style.

TIP

THE CENTER OF GRAVITY AND THE INCLINE OF THE BODY ALTER HOW THE RUNNER IS PERCEIVED. BRINGING THE CENTER OF GRAVITY FORWARD CREATES A MORE FRIVOLOUS IMPRESSION.

Drawing "ghost" legs (a technique incorporating the "after image") creates a comical running style while bringing out a high-speed sense of motion at the same time.

Four heads tall

Even if the running pose is the same as a smaller figure's, it's possible to show more detailed expression on a taller figure. The use of different perspectives increases the impact.

The chibi technique of showing flying sweat.

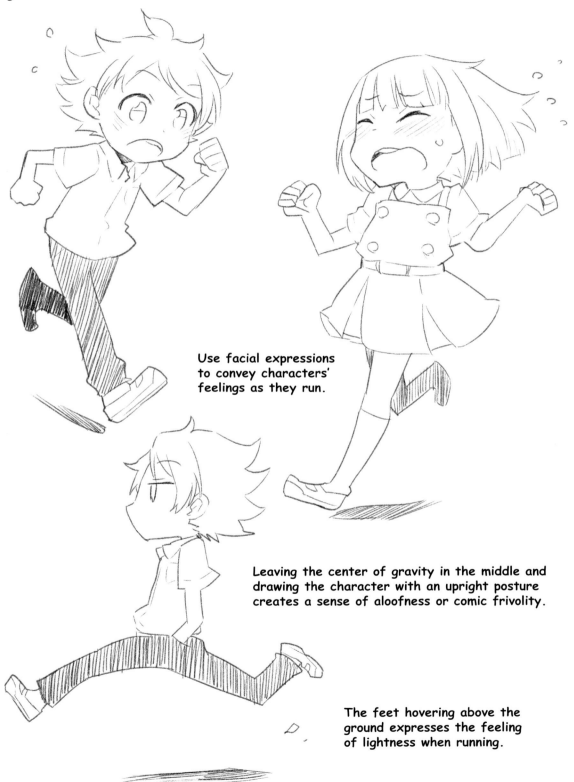

Use facial expressions to convey characters' feelings as they run.

Leaving the center of gravity in the middle and drawing the character with an upright posture creates a sense of aloofness or comic frivolity.

The feet hovering above the ground expresses the feeling of lightness when running.

SITTING

FOR SUCH A COMMON, EVERYDAY POSE, SITTING IS ACTUALLY HARD TO GET RIGHT. WITHOUT AN UNDERSTANDING OF HOW THE JOINTS OF THE UPPER AND LOWER BODY MOVE, THE DRAWING WILL APPEAR UNNATURAL. IF THE FEET ARE FACING FRONT, PERSPECTIVE ALSO HAS TO BE TAKEN INTO ACCOUNT.

Two heads tall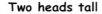

Sitting is one of the poses that can convey the adorable side of chibi style. Add detailed gestures to differentiate your characters.

Add a manga-style symbol to indicate breathing a sigh of relief.

When drawing a character sitting on the floor, a simple pose without too much detail in the joints yields a cute result. The vacant facial expression works well too.

If seating your character in a chair, make sure to distort the chair as well.

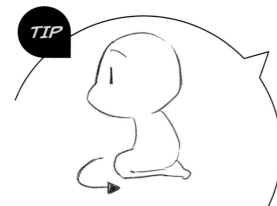

TIP

IF THE HEAD IS LARGE IN PROPORTION TO THE BODY, THE LEGS SHOULDN'T BE LONG ENOUGH TO TUCK BENEATH THE BODY, BUT USE THE MAGIC OF MANGA TO DRAW THEM AS IF THEY ARE. THAT WAY, THEY WON'T APPEAR TO BE TOO LONG.

These wavy lines indicate pins and needles in the feet from sitting too long in that position.

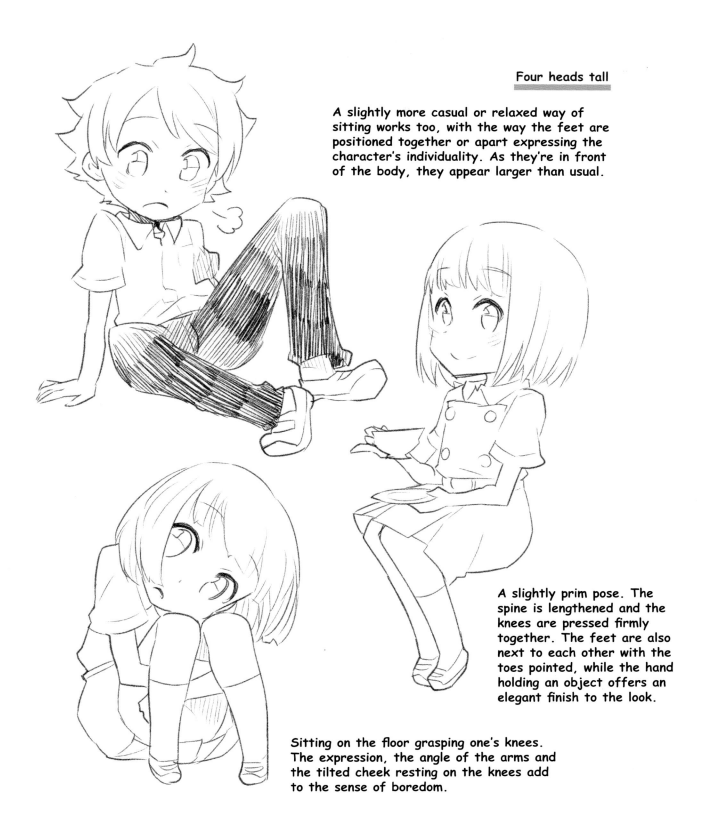

Four heads tall

A slightly more casual or relaxed way of sitting works too, with the way the feet are positioned together or apart expressing the character's individuality. As they're in front of the body, they appear larger than usual.

A slightly prim pose. The spine is lengthened and the knees are pressed firmly together. The feet are also next to each other with the toes pointed, while the hand holding an object offers an elegant finish to the look.

Sitting on the floor grasping one's knees. The expression, the angle of the arms and the tilted cheek resting on the knees add to the sense of boredom.

POSES WITH MOTION

TRIPPING AND FALLING, LEAPING INTO THE AIR: THESE ARE MOTION-BASED POSES THAT ARE DISTORTED TO START WITH, SO THEY'RE USEFUL FOR INCORPORATING INTO ANIMATED, LIVELY SITUATIONS. TRY YOUR HAND AT A FEW OF THESE FLUIDLY PHYSICAL SCENARIOS.

Two heads tall

Stubbing one's toe is an unplanned movement, so the trick to capturing it is to add a startled or troubled expression.

Add a symbol indicating surprise at an angle above the figure.

The face and body are squashed flat from the impact of falling over.

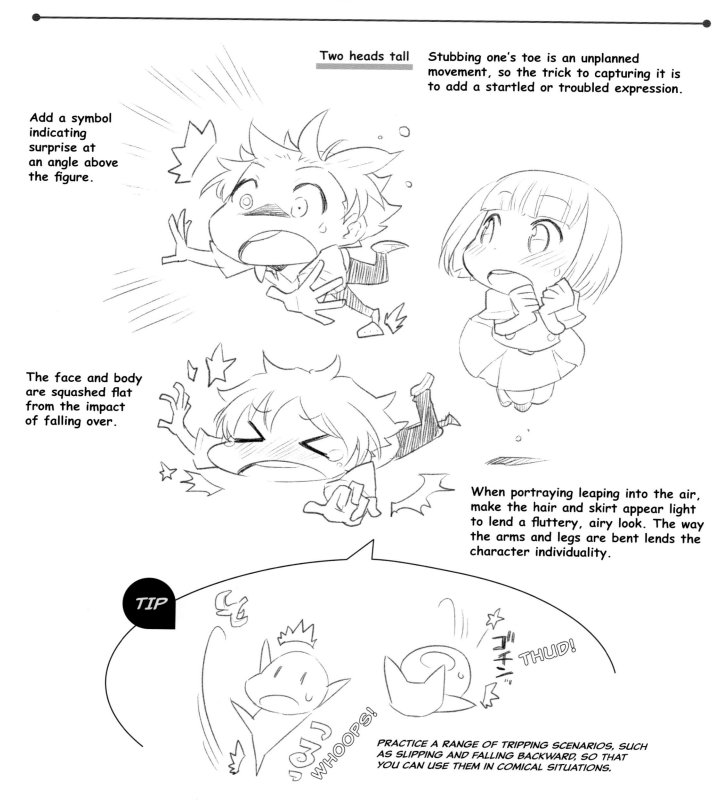

When portraying leaping into the air, make the hair and skirt appear light to lend a fluttery, airy look. The way the arms and legs are bent lends the character individuality.

TIP

WHOOPS!

THUD!

PRACTICE A RANGE OF TRIPPING SCENARIOS, SUCH AS SLIPPING AND FALLING BACKWARD, SO THAT YOU CAN USE THEM IN COMICAL SITUATIONS.

<u>Four heads tall</u>

When drawing a stumbling character, flailing limbs make the character look awkward, giving your drawing that hint of realism.

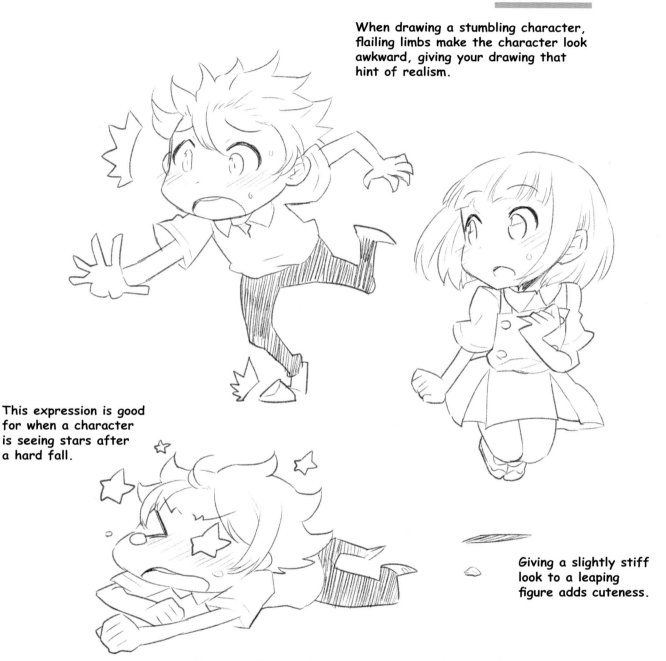

This expression is good for when a character is seeing stars after a hard fall.

Giving a slightly stiff look to a leaping figure adds cuteness.

Falling face forward leaves a character splayed and vulnerable, a potentially useful pose when trying to convey another side to an otherwise serious personality.

EXPRESSIONS USING THE HANDS

WHILE THE HANDS ARE JUST ONE PART OF THE BODY, THEIR POSITIONING, MOVEMENT AND PLACEMENT CAN GO A LONG WAY IN EXPRESSING THE CHARACTER'S EMOTIONS.

Two heads tall When drawing a character raising her hand, if you stick to the rules of chibi, the arm will be too short and it won't look as if the hand's raised. Make the arm longer and the hand bigger instead.

When drawing a character waving, use vigorous "ghost" lines (or after images) to suggest the chibi style. Make sure to alter the facial expression too.

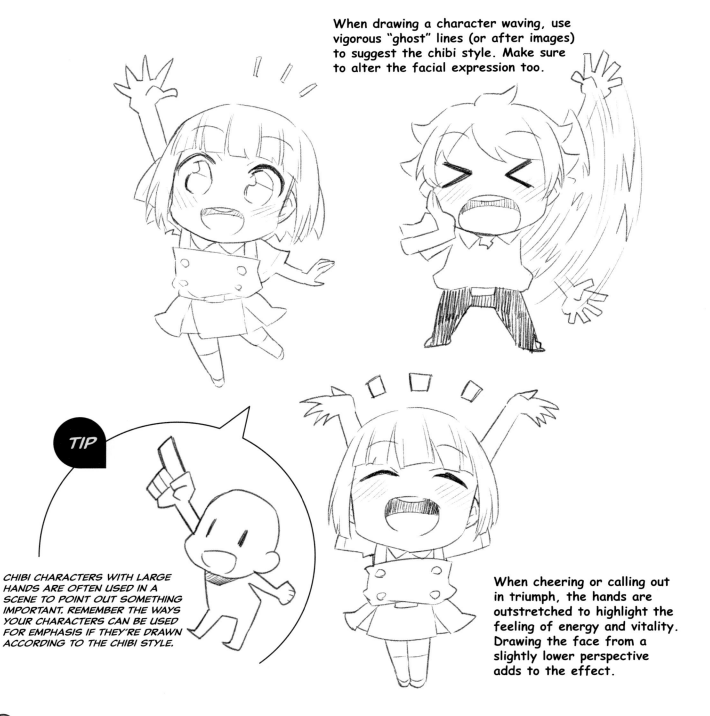

TIP

CHIBI CHARACTERS WITH LARGE HANDS ARE OFTEN USED IN A SCENE TO POINT OUT SOMETHING IMPORTANT. REMEMBER THE WAYS YOUR CHARACTERS CAN BE USED FOR EMPHASIS IF THEY'RE DRAWN ACCORDING TO THE CHIBI STYLE.

When cheering or calling out in triumph, the hands are outstretched to highlight the feeling of energy and vitality. Drawing the face from a slightly lower perspective adds to the effect.

Four heads tall

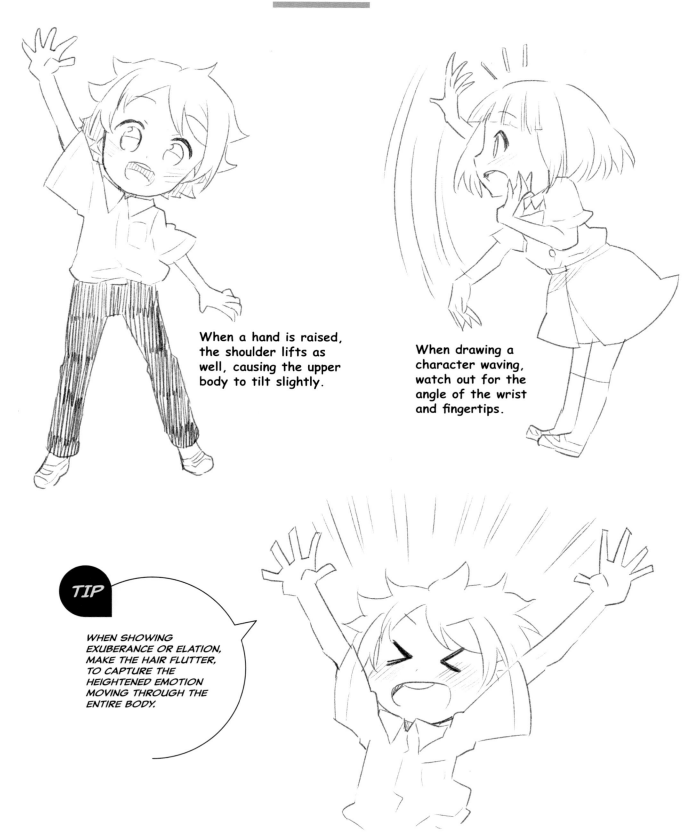

When a hand is raised, the shoulder lifts as well, causing the upper body to tilt slightly.

When drawing a character waving, watch out for the angle of the wrist and fingertips.

TIP

WHEN SHOWING EXUBERANCE OR ELATION, MAKE THE HAIR FLUTTER, TO CAPTURE THE HEIGHTENED EMOTION MOVING THROUGH THE ENTIRE BODY.

ON THE ATTACK

FIGHTS ARE AN ESSENTIAL ELEMENT IN LOTS OF MANGA. ONCE YOU'VE MASTERED THE CHARACTERS' MOVEMENTS, TRY DRAWING A FIERCELY CONTESTED FIGHT SCENE.

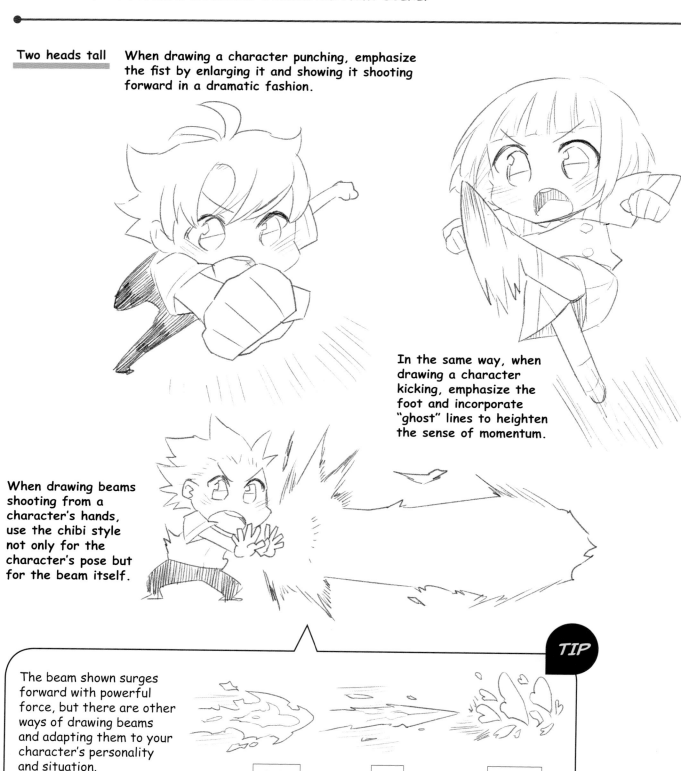

Two heads tall

When drawing a character punching, emphasize the fist by enlarging it and showing it shooting forward in a dramatic fashion.

In the same way, when drawing a character kicking, emphasize the foot and incorporate "ghost" lines to heighten the sense of momentum.

When drawing beams shooting from a character's hands, use the chibi style not only for the character's pose but for the beam itself.

TIP

The beam shown surges forward with powerful force, but there are other ways of drawing beams and adapting them to your character's personality and situation.

flame

ice

hearts

Four heads tall

Using chibi techniques even as the character's head-to-body ratio increases lends scenes the drama and power of action movies. Make sure you can draw the figure from the front, the side and from other various angles as well.

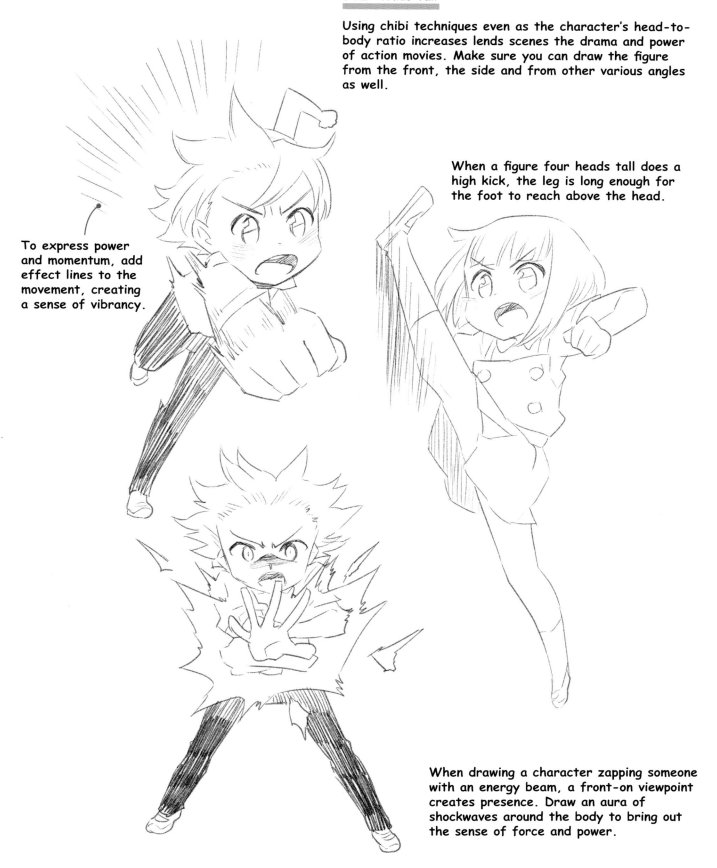

When a figure four heads tall does a high kick, the leg is long enough for the foot to reach above the head.

To express power and momentum, add effect lines to the movement, creating a sense of vibrancy.

When drawing a character zapping someone with an energy beam, a front-on viewpoint creates presence. Draw an aura of shockwaves around the body to bring out the sense of force and power.

FEELING DEFENSIVE

IF YOUR CHARACTER ISN'T LAUNCHING AN ASSAULT, MAYBE HE OR SHE IS ON THE DEFENSE. WHEN DRAWN IN THE CHIBI STYLE, EVEN A REALISTIC FIGHT SCENE WILL HAVE A SOMEWHAT LIGHTHEARTED ASPECT TO IT.

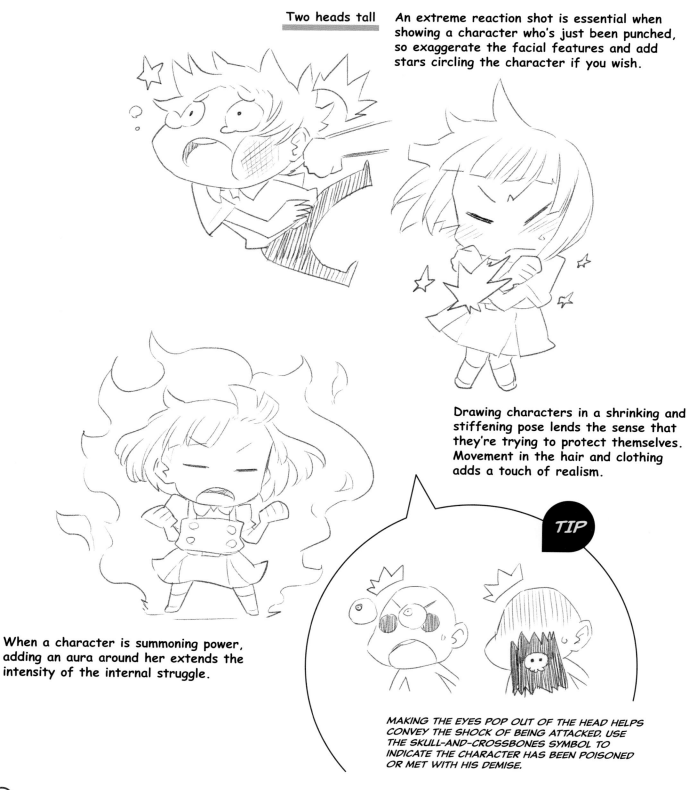

Two heads tall

An extreme reaction shot is essential when showing a character who's just been punched, so exaggerate the facial features and add stars circling the character if you wish.

Drawing characters in a shrinking and stiffening pose lends the sense that they're trying to protect themselves. Movement in the hair and clothing adds a touch of realism.

TIP

When a character is summoning power, adding an aura around her extends the intensity of the internal struggle.

MAKING THE EYES POP OUT OF THE HEAD HELPS CONVEY THE SHOCK OF BEING ATTACKED. USE THE SKULL-AND-CROSSBONES SYMBOL TO INDICATE THE CHARACTER HAS BEEN POISONED OR MET WITH HIS DEMISE.

Four heads tall

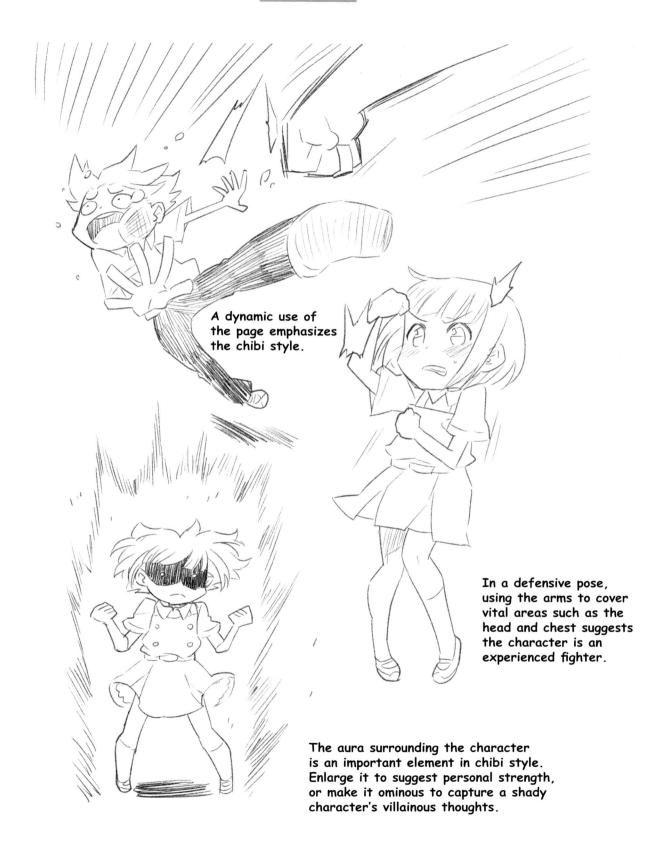

A dynamic use of the page emphasizes the chibi style.

In a defensive pose, using the arms to cover vital areas such as the head and chest suggests the character is an experienced fighter.

The aura surrounding the character is an important element in chibi style. Enlarge it to suggest personal strength, or make it ominous to capture a shady character's villainous thoughts.

OTHER LARGE MOVEMENTS

TURNING AROUND, GETTING UP OFF THE GROUND, RECEIVING A SHOCK: THERE'S A RANGE OF LARGER MOTIONS THAT YOU'LL HAVE TO MASTER IN THE CHIBI STYLE. THEY MAY INVOLVE A HIGHER DEGREE OF PRECISION AND DETAIL, BUT THEY'RE HIGHLY USEFUL WHEN CREATING ILLUSTRATIONS FOR A STORY.

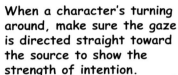

Two heads tall

When a character's turning around, make sure the gaze is directed straight toward the source to show the strength of intention.

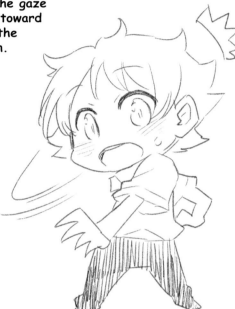

Effect lines are an important element when showing a character standing up quickly. A flurry of lines creates the impression of snapping to attention.

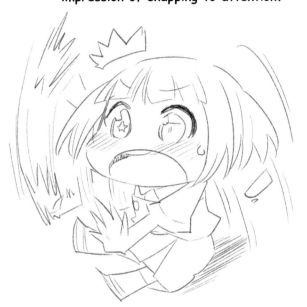

TIP

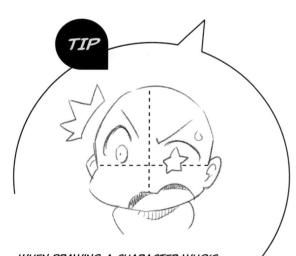

WHEN DRAWING A CHARACTER WHO'S SURPRISED, AN ASYMMETRICAL EXPRESSION ADDS IMPACT DUE TO THE HEIGHTENED ATTENTION GIVEN THE FACIAL STRUCTURE. BUT MAKE SURE NOT TO OVERDO IT.

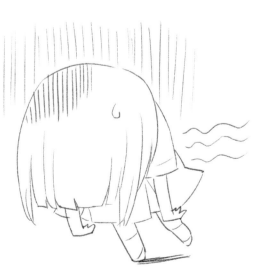

To evoke a look of exhaustion, add wobbly effect lines to highlight the sense of physical weakness.

Four heads tall

The corner pose, or the moment when the character suddenly gets up. The motion in the limbs is useful for expressing tension and conveying the situation.

Making the eyes large and wide open shows that the character has turned around for a reason. Drawing in movement lines adds to the effect.

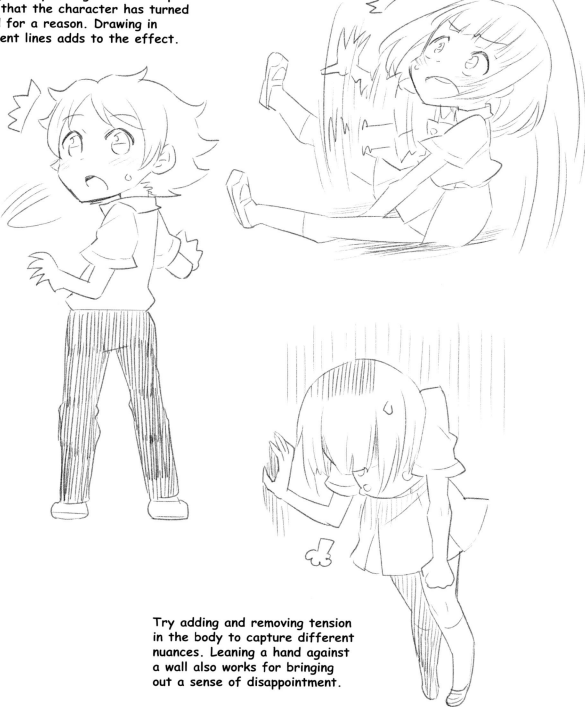

Try adding and removing tension in the body to capture different nuances. Leaning a hand against a wall also works for bringing out a sense of disappointment.

MAKING AN APPEARANCE

WHAT SORT OF TECHNIQUE IS NEEDED WHEN A HERO MAKES AN APPEARANCE? IF YOU WANT YOUR CHARACTER TO MAKE A MEMORABLE ENTRANCE, IT'S IMPORTANT TO MASTER THESE POSES.

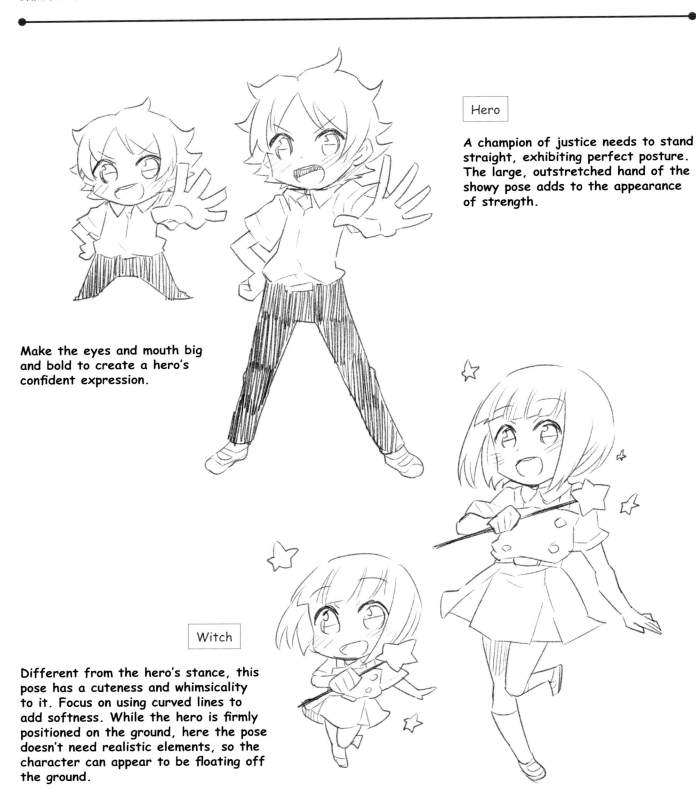

Hero

A champion of justice needs to stand straight, exhibiting perfect posture. The large, outstretched hand of the showy pose adds to the appearance of strength.

Make the eyes and mouth big and bold to create a hero's confident expression.

Witch

Different from the hero's stance, this pose has a cuteness and whimsicality to it. Focus on using curved lines to add softness. While the hero is firmly positioned on the ground, here the pose doesn't need realistic elements, so the character can appear to be floating off the ground.

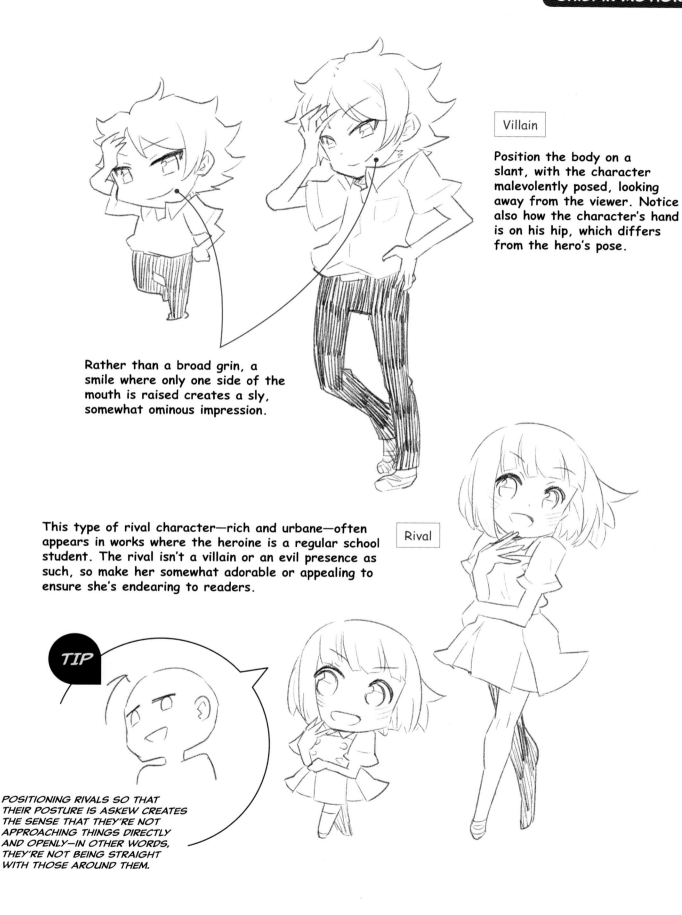

Villain

Position the body on a slant, with the character malevolently posed, looking away from the viewer. Notice also how the character's hand is on his hip, which differs from the hero's pose.

Rather than a broad grin, a smile where only one side of the mouth is raised creates a sly, somewhat ominous impression.

This type of rival character—rich and urbane—often appears in works where the heroine is a regular school student. The rival isn't a villain or an evil presence as such, so make her somewhat adorable or appealing to ensure she's endearing to readers.

Rival

TIP

POSITIONING RIVALS SO THAT THEIR POSTURE IS ASKEW CREATES THE SENSE THAT THEY'RE NOT APPROACHING THINGS DIRECTLY AND OPENLY—IN OTHER WORDS, THEY'RE NOT BEING STRAIGHT WITH THOSE AROUND THEM.

VARIOUS POSES

ALONG WITH THE FACE, HAIRSTYLE AND CLOTHING, THE POSE IS AN EFFECTIVE WAY OF EXPRESSING A CHARACTER'S PERSONALITY. PRACTICE UNTIL YOU'RE ABLE TO DRAW CHARACTERS IN POSES THAT SUIT THEM AND DISTINGUISH THEM FROM THE OTHER CHIBI CREATIONS AROUND THEM.

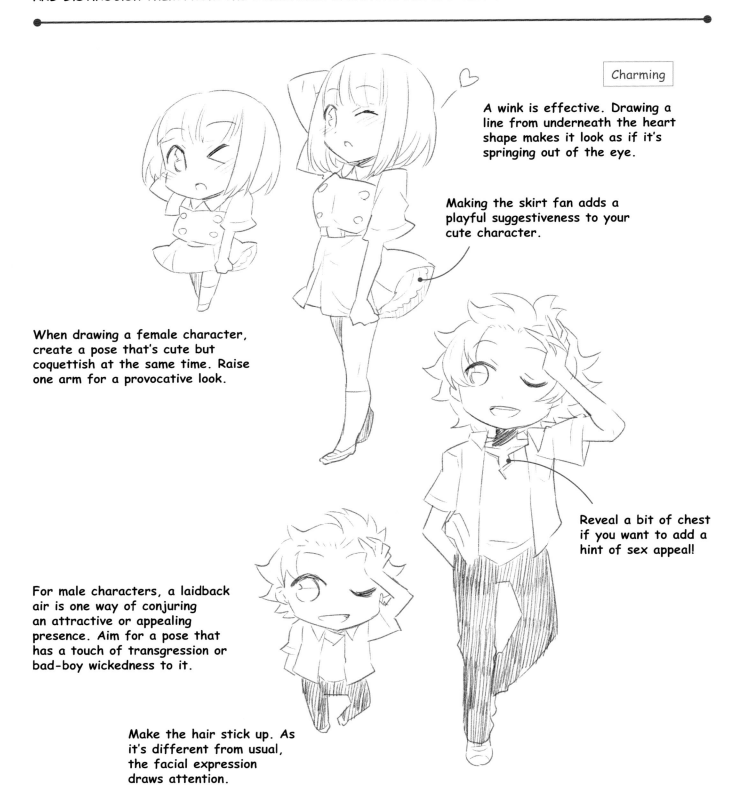

Charming

A wink is effective. Drawing a line from underneath the heart shape makes it look as if it's springing out of the eye.

Making the skirt fan adds a playful suggestiveness to your cute character.

When drawing a female character, create a pose that's cute but coquettish at the same time. Raise one arm for a provocative look.

Reveal a bit of chest if you want to add a hint of sex appeal!

For male characters, a laidback air is one way of conjuring an attractive or appealing presence. Aim for a pose that has a touch of transgression or bad-boy wickedness to it.

Make the hair stick up. As it's different from usual, the facial expression draws attention.

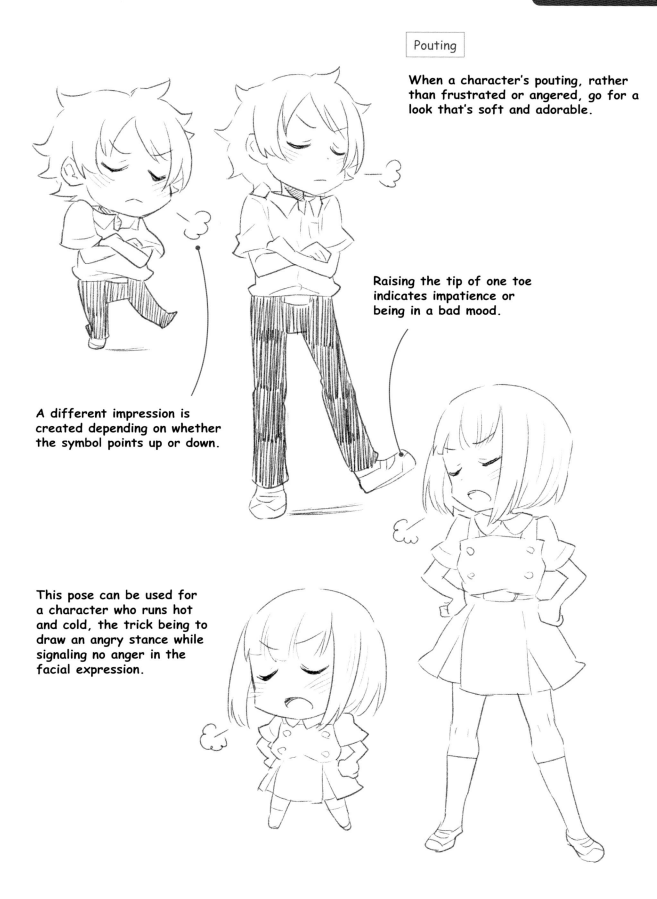

Pouting

When a character's pouting, rather than frustrated or angered, go for a look that's soft and adorable.

Raising the tip of one toe indicates impatience or being in a bad mood.

A different impression is created depending on whether the symbol points up or down.

This pose can be used for a character who runs hot and cold, the trick being to draw an angry stance while signaling no anger in the facial expression.

At wit's end

Trying to endure an annoying situation is expressed by shaking a fist in anger. Showing the hands trembling is also an effective inclusion. Draw short wavy lines emanating from the fist.

In contrast to the slight exasperation shown on the previous page, this pose indicates trying to conceal or contain a mounting sense of anger.

The legs are braced as if trying to keep the anger under control. Bring out the look of tension in the bent knees.

Here the character's just barely managing to hold back a scream. Show the whole body trembling and the rigid facial expression signaling an attempt to stay in control.

TIP

USING A CHIBI-STYLE FACIAL EXPRESSION IS ANOTHER WAY OF INDICATING THAT THE CHARACTER'S TRYING TO CONTAIN HIS RAGE.

For female characters, rather than showing tension in the knees and elbows, express it in the tips of the fingers and the heels.

Checked out

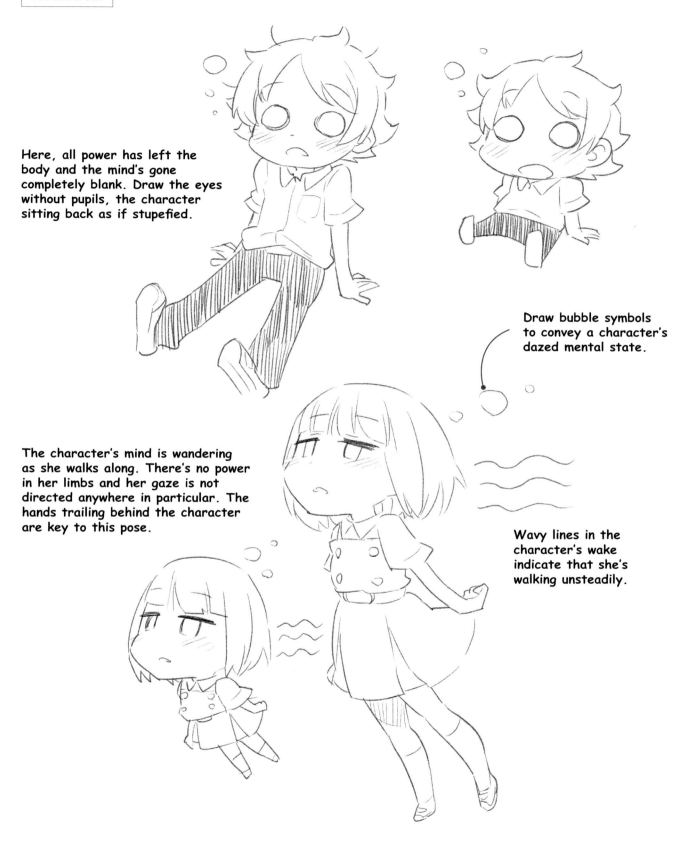

Here, all power has left the body and the mind's gone completely blank. Draw the eyes without pupils, the character sitting back as if stupefied.

Draw bubble symbols to convey a character's dazed mental state.

The character's mind is wandering as she walks along. There's no power in her limbs and her gaze is not directed anywhere in particular. The hands trailing behind the character are key to this pose.

Wavy lines in the character's wake indicate that she's walking unsteadily.

Sulking

This pose takes on a charming air when the character is drawn chibi style. Make sure to incorporate comic elements and details into the pose as well as the facial expression.

Draw effect lines to indicate tension.

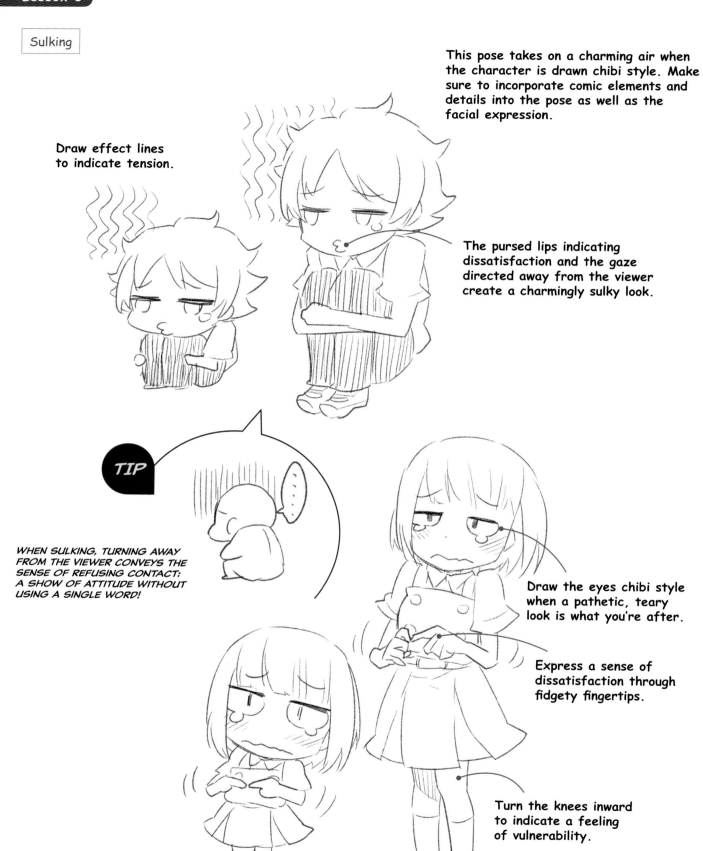

The pursed lips indicating dissatisfaction and the gaze directed away from the viewer create a charmingly sulky look.

TIP

WHEN SULKING, TURNING AWAY FROM THE VIEWER CONVEYS THE SENSE OF REFUSING CONTACT: A SHOW OF ATTITUDE WITHOUT USING A SINGLE WORD!

Draw the eyes chibi style when a pathetic, teary look is what you're after.

Express a sense of dissatisfaction through fidgety fingertips.

Turn the knees inward to indicate a feeling of vulnerability.

Relaxed

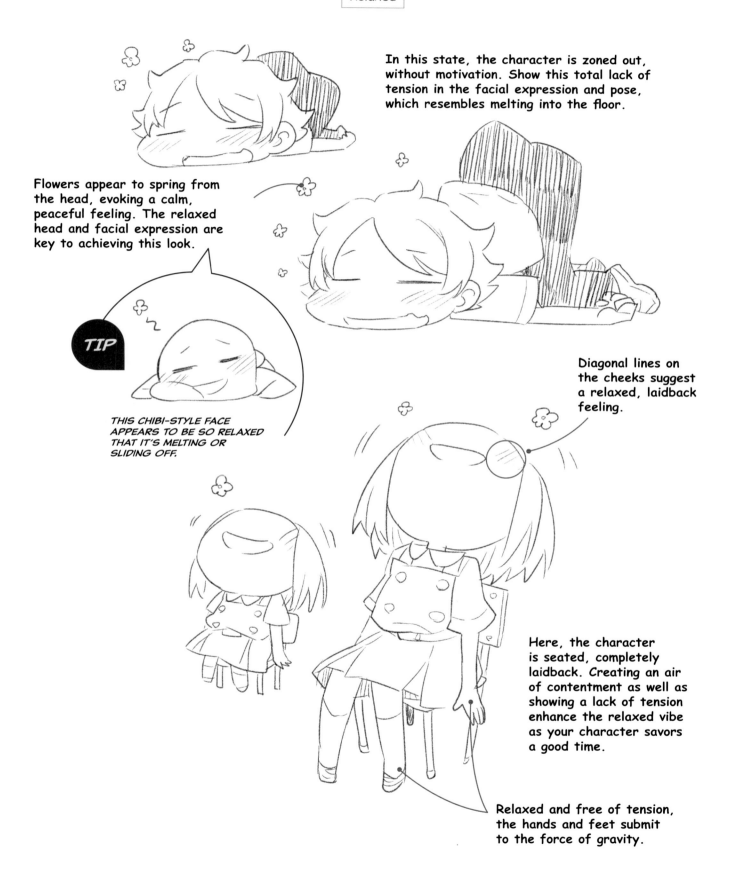

In this state, the character is zoned out, without motivation. Show this total lack of tension in the facial expression and pose, which resembles melting into the floor.

Flowers appear to spring from the head, evoking a calm, peaceful feeling. The relaxed head and facial expression are key to achieving this look.

TIP

THIS CHIBI-STYLE FACE APPEARS TO BE SO RELAXED THAT IT'S MELTING OR SLIDING OFF.

Diagonal lines on the cheeks suggest a relaxed, laidback feeling.

Here, the character is seated, completely laidback. Creating an air of contentment as well as showing a lack of tension enhance the relaxed vibe as your character savors a good time.

Relaxed and free of tension, the hands and feet submit to the force of gravity.

Shocked

Chibi style is designed for rendering expressions of shock. Push the facial expression and pose just to the point of overexaggeration.

Everything is standing on end from shock.

The eyes are mere pinpricks due to shock. Making the left and right eye different shapes increases the sense of confusion.

TIP

MAKING ONLY THE FACE LARGER EMPHASIZES THE SENSE OF SHOCK.

This symbol indicates alarm. As it expresses surprise, it suggests the buzz of an electric shock.

The shock is so great that the mouth extends far beyond the facial outline.

The character bounces off the ground in shock.

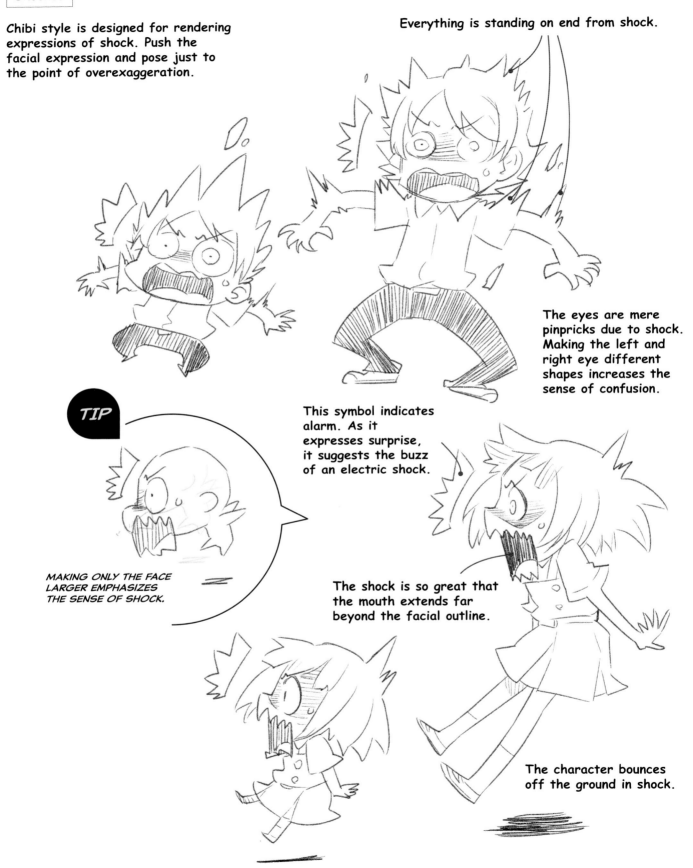

Sorrowful

The character's gripped by painful emotions. Not rage but not sadness either, here the sorrow is more subtle, so it calls for a more nuanced facial expression. The faraway look in the eyes is key.

The hand over the chest emphasizes that the character is experiencing heartache.

There's a lack of power in the character's stance. Don't go so far as to make him pigeon-toed, but direct the toes slightly inward.

One way to draw this look is to show the face turned down, unable to bear painful emotions.

Bringing both arms behind the back brings out a sense of uncertainty.

USING WORDS AND ONOMATOPOEIA TO EXPRESS EMOTION

WITH THE CHIBI STYLE, WORDS CAN BE USED TO EXPRESS FEELINGS. USE EVOCATIVE LETTERING TO INCORPORATE ONOMATOPOEIA—SUCH AS "CRASH"—INTO YOUR ILLUSTRATIONS, BUT ALSO MIMETIC WORDS SUCH AS "HMM" AND "SIGH."

Manually drawing in the words for sounds is a device often used in manga, with these words becoming an important element in a chibi-style illustration. Play around with the shape and size of the letters to emphasize a word's meaning.

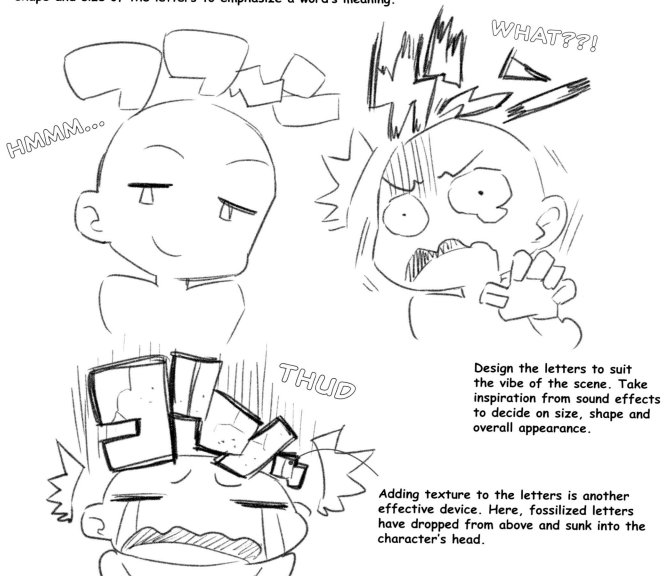

Design the letters to suit the vibe of the scene. Take inspiration from sound effects to decide on size, shape and overall appearance.

Adding texture to the letters is another effective device. Here, fossilized letters have dropped from above and sunk into the character's head.

CHIBI CHARACTERS

CHIBI AT SCHOOL

IN MANGA FOR YOUNG BOYS AND GIRLS, THE MAIN CHARACTER IS OFTEN A STUDENT. SO HERE WE'RE TAKING A CLOSE LOOK AT CHIBI IN THE CLASSROOM.

School uniforms

Depending on its design and how it's drawn, a uniform can suit various kinds of characters. Playing around with the design can be fun!

Six heads tall

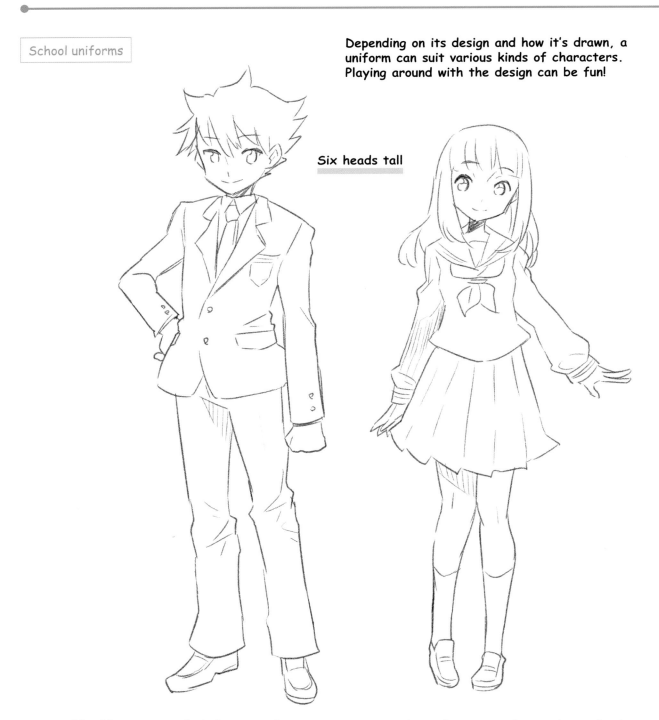

The blazer is one look for a student. Combined with ruffled hair, it lends your main characters an individual style. For a reserved, quiet protagonist, make the blazer neat and tidy and go for a smooth, groomed hairstyle.

The sailor suit evokes a classical, clean image that works best on a character who is not too over the top. Use different colors to distinguish the characters from one another.

When applying chibi style to a blazer, use your intuition to capture the crisp, sharp feeling of the uniform. Adding in the small details— such as the necktie and the school badge on the breast pocket—is also key.

Four heads tall

Two heads tall

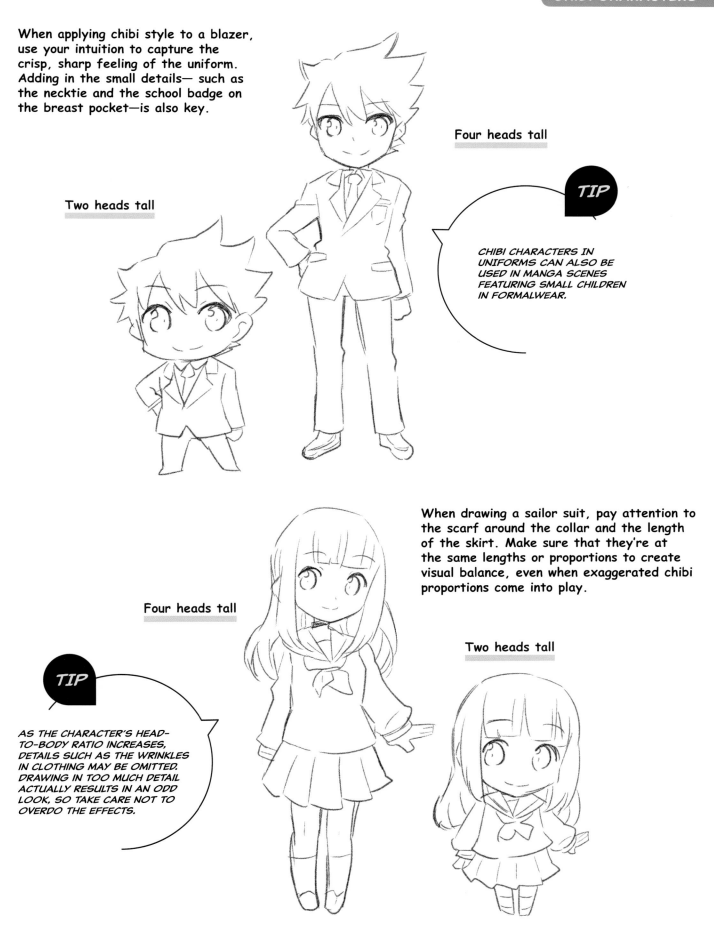

TIP

CHIBI CHARACTERS IN UNIFORMS CAN ALSO BE USED IN MANGA SCENES FEATURING SMALL CHILDREN IN FORMALWEAR.

When drawing a sailor suit, pay attention to the scarf around the collar and the length of the skirt. Make sure that they're at the same lengths or proportions to create visual balance, even when exaggerated chibi proportions come into play.

Four heads tall

Two heads tall

TIP

AS THE CHARACTER'S HEAD-TO-BODY RATIO INCREASES, DETAILS SUCH AS THE WRINKLES IN CLOTHING MAY BE OMITTED. DRAWING IN TOO MUCH DETAIL ACTUALLY RESULTS IN AN ODD LOOK, SO TAKE CARE NOT TO OVERDO THE EFFECTS.

Sub-characters

Rival female character

Four heads tall

As she's the protagonist's arch rival, design this character with a touch of cool, but don't forget to give her some endearing qualities.

Two heads tall

Characters who are easily flattered

Four heads tall

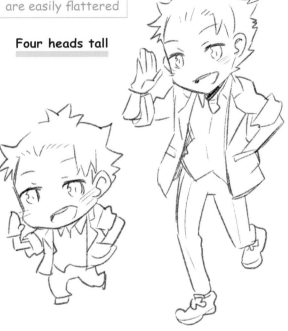

Two heads tall

Key to this look are the rolled-up sleeves and the bright, cheerful expression. Don't forget to convey friendliness with the pose.

Four heads tall

Two heads tall

An admired senior student

As the most exemplary student in the school, every aspect of this character's uniform is flawless. Add a gorgeous hairstyle, bow in the hair and other accessories to create a model student almost to the point of excess.

Dress this character in a uniform in team colors. Compared with baseball players and other athletes, the hairstyle can be slightly flirtier to create a look that's popular with girls.

Four heads tall

Two heads tall

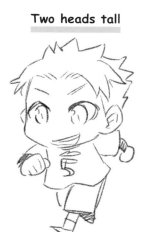

Four heads tall

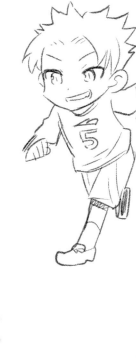

Two heads tall

The most popular girl in school

Make this character's hairstyle and outfit adorable, with puffed sleeves, a miniskirt, knee socks and whatever else adds flair to the uniform.

Four heads tall

Two heads tall

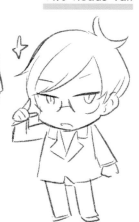

Class president

A rigid, strait-laced seriousness defines this character. The key element here is a stiffness in the line of the body and how the uniform is worn, compared with that of other students.

Frequently occurring scenes

The trick to getting these frequently occurring scenes right is to make sure not only the character but also the movements are given the chibi treatment.

Sleeping at a desk

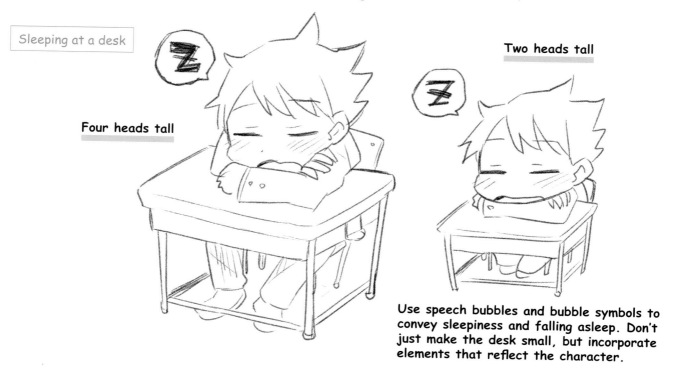

Four heads tall

Two heads tall

Use speech bubbles and bubble symbols to convey sleepiness and falling asleep. Don't just make the desk small, but incorporate elements that reflect the character.

Four heads tall

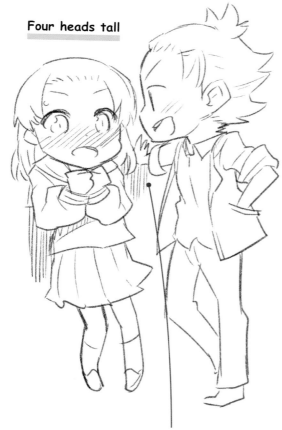

At four heads tall, there's no need to alter the proportions.

Trapping someone by a wall

With this pose, drawing figures two heads tall without altering their proportions can result in them being unable to reach the wall. So tweak the proportions, elongating the arm for a natural look.

Two heads tall

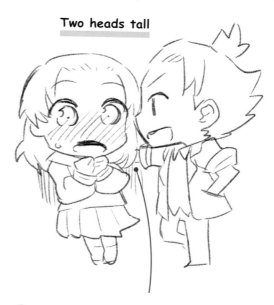

Expressing the situation through the pose is difficult at two heads tall, so make use of the facial expression instead.

Four heads tall

Colliding in the hall

The reactions after bumping into each other convey the characters' personalities. Here, the key point is the slightly foolish expression of the character whose glasses have been knocked off from the impact.

Two heads tall

At two heads tall, apply chibi effects to show the action of the collision itself.

Four heads tall

Handing over a love letter

Two heads tall

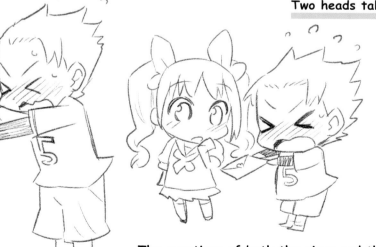

The reactions of both the giver and the recipient are important in a love letter scene. Here, the boy from the soccer team is all seriousness while the most popular girl in school reacts in astonishment.

CHARACTERS FROM FANTASY WORLDS

WHILE THERE'S NOTHING BUT VARIETY IN THE FANTASY GENRE, HERE WE WILL LOOK AT FANTASY WITH JAPANESE ORIGINS. WEAPONS, THE DESIGN OF CLOTHING AND OTHER ITEMS CAN BE USED TO BRING OUT THE INDIVIDUALITY OF YOUR CHARACTERS.

Main character

Six heads tall

Protagonists in fantasy worlds often have "hero" as their job description. Draw them in simple clothing covered in capes, headgear and other elements typical of hero attire.

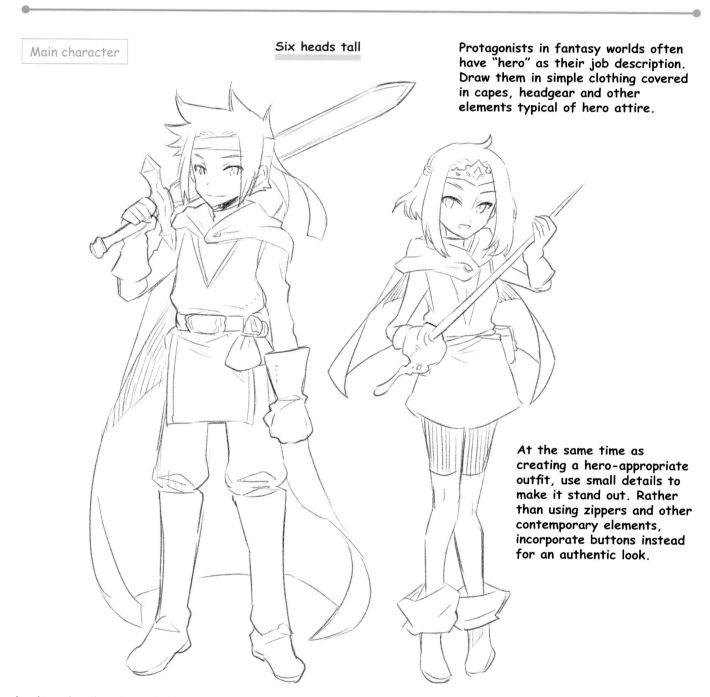

At the same time as creating a hero-appropriate outfit, use small details to make it stand out. Rather than using zippers and other contemporary elements, incorporate buttons instead for an authentic look.

Don't make the character's equipment too heavy: Leather gloves and shoes are the norm. Give serious consideration to the grip of the sword so that the weapon doesn't come across as being too heavy. Making the character look cool and in charge is of course a top priority.

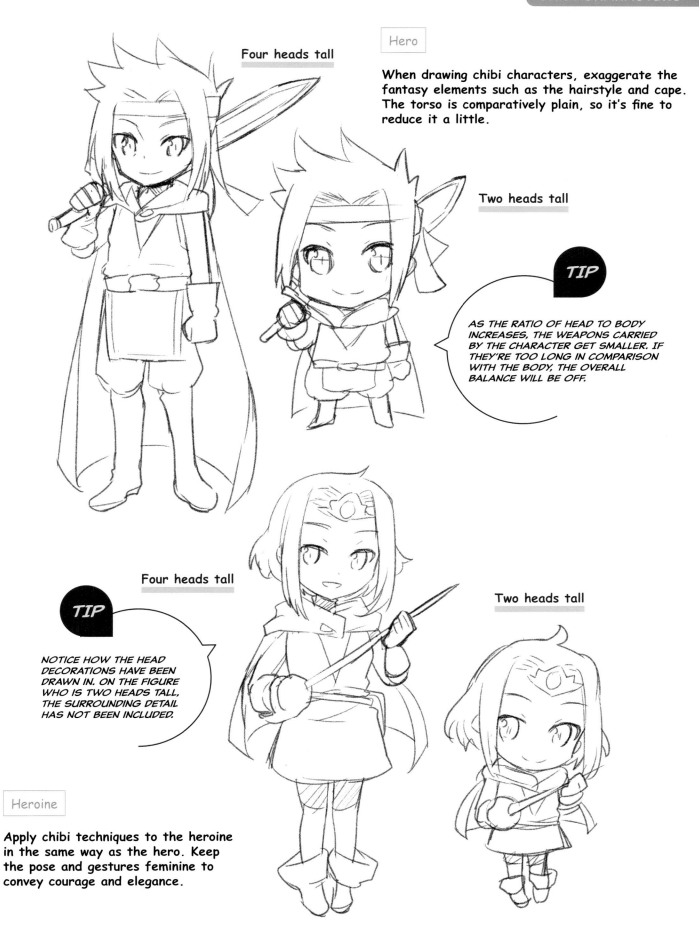

Four heads tall

Hero

When drawing chibi characters, exaggerate the fantasy elements such as the hairstyle and cape. The torso is comparatively plain, so it's fine to reduce it a little.

Two heads tall

TIP

AS THE RATIO OF HEAD TO BODY INCREASES, THE WEAPONS CARRIED BY THE CHARACTER GET SMALLER. IF THEY'RE TOO LONG IN COMPARISON WITH THE BODY, THE OVERALL BALANCE WILL BE OFF.

Four heads tall

TIP

NOTICE HOW THE HEAD DECORATIONS HAVE BEEN DRAWN IN. ON THE FIGURE WHO IS TWO HEADS TALL, THE SURROUNDING DETAIL HAS NOT BEEN INCLUDED.

Two heads tall

Heroine

Apply chibi techniques to the heroine in the same way as the hero. Keep the pose and gestures feminine to convey courage and elegance.

Sub-characters

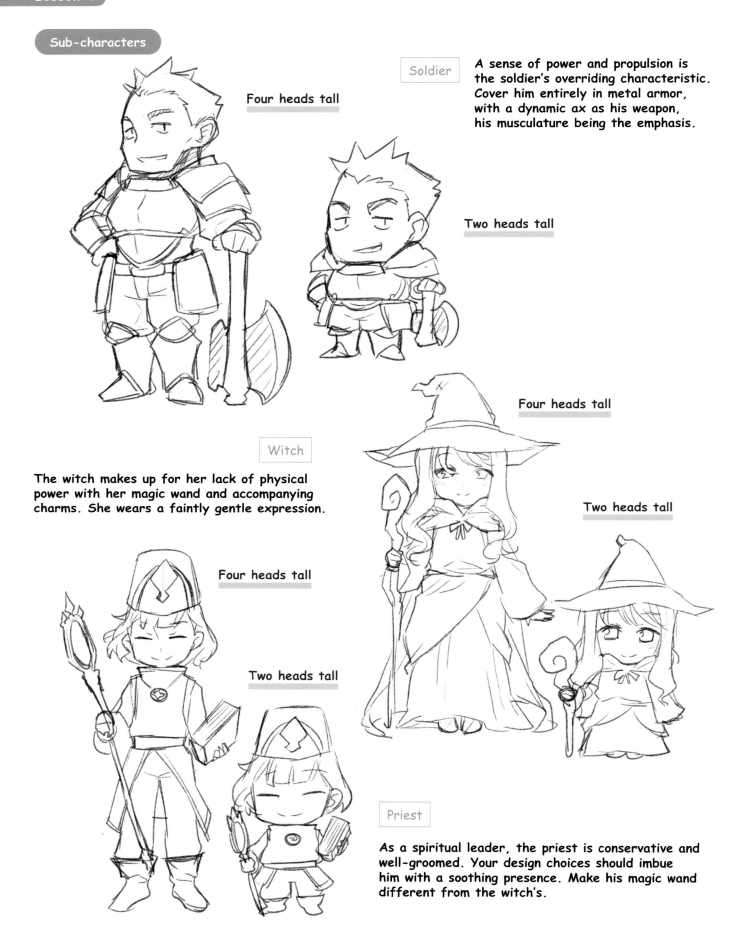

Four heads tall

Soldier

A sense of power and propulsion is the soldier's overriding characteristic. Cover him entirely in metal armor, with a dynamic ax as his weapon, his musculature being the emphasis.

Two heads tall

Four heads tall

Witch

The witch makes up for her lack of physical power with her magic wand and accompanying charms. She wears a faintly gentle expression.

Two heads tall

Four heads tall

Two heads tall

Priest

As a spiritual leader, the priest is conservative and well-groomed. Your design choices should imbue him with a soothing presence. Make his magic wand different from the witch's.

Four heads tall

Two heads tall

Princess

Make the skirt puff out around the body and draw her in a calm pose to lend an air of charisma.

Four heads tall

Two heads tall

Fairy

Draw this character to be a bit of a tomboy with a happy-go-lucky air. Incorporating berries, leaves and other natural elements into her costume highlights her carefree spirit.

Four heads tall

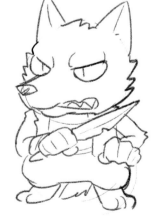

Two heads tall

Monster This werewolf bandit is just one example of a monster. His outfit has been stolen from a human and is shabby and falling to pieces. Emphasize the face, feet, tail and other characteristic lines of the body.

Sub-characters

Fighting with a sword

Harnessing the dynamic chibi style, draw your character on the attack. Use ghost lines (the after image of the sword, for example) to evoke a sense of intensity and speed.

Two heads tall

Four heads tall

Four heads tall

Casting a spell

The floating look of the cape and hair evokes the unleashing of magic power. The facial expression is also key.

Two heads tall

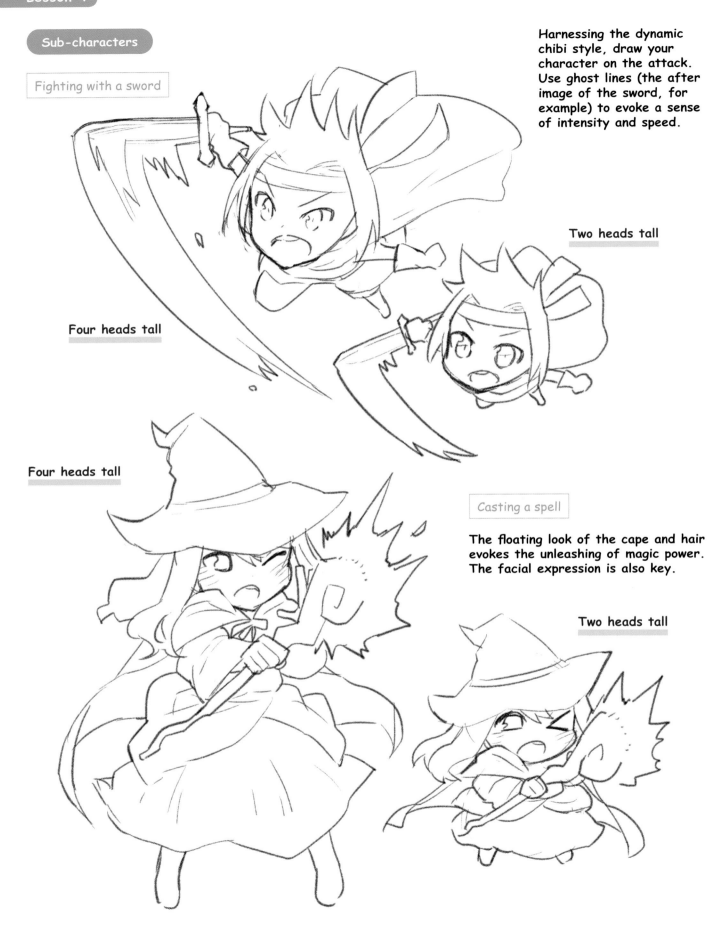

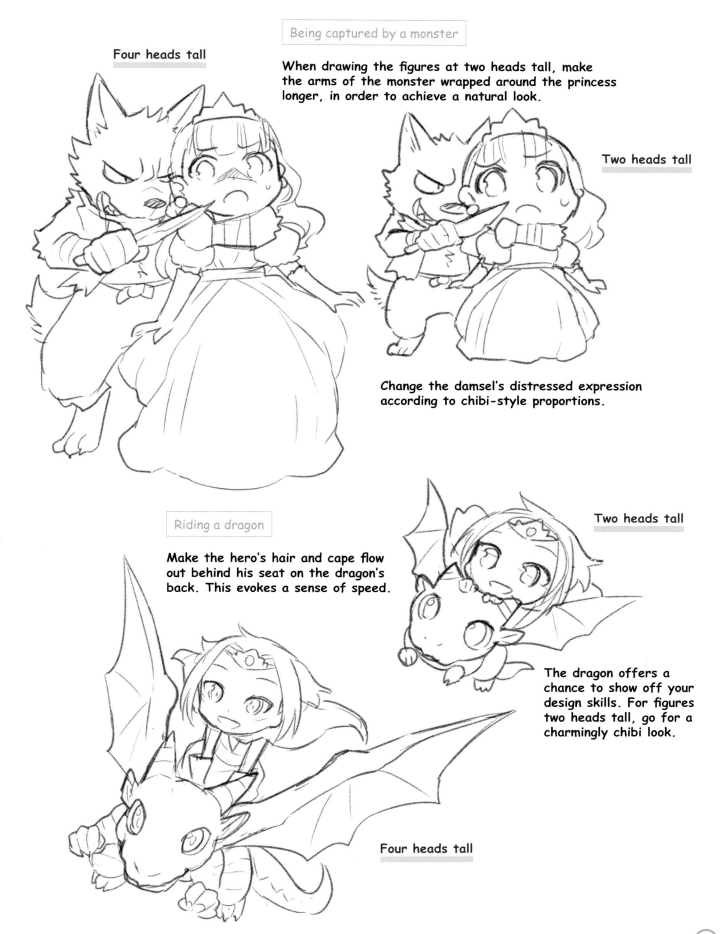

Four heads tall

Being captured by a monster

When drawing the figures at two heads tall, make the arms of the monster wrapped around the princess longer, in order to achieve a natural look.

Two heads tall

Change the damsel's distressed expression according to chibi-style proportions.

Riding a dragon

Make the hero's hair and cape flow out behind his seat on the dragon's back. This evokes a sense of speed.

Two heads tall

The dragon offers a chance to show off your design skills. For figures two heads tall, go for a charmingly chibi look.

Four heads tall

ROBOT OR SCI-FI CHARACTERS

FOR ROBOT OR SCI-FI CHARACTER INHABITING OUTER SPACE, GIVE THEIR CLOTHING AND ACCESSORIES A FUTURISTIC FEEL. DESIGNING AN ARRAY OF ROBOTS IS FUN!

Main character

Quirky, unorthodox characters are the norm in the world of robots and science fiction. Create variation while maintaining unique physiques and physical attributes.

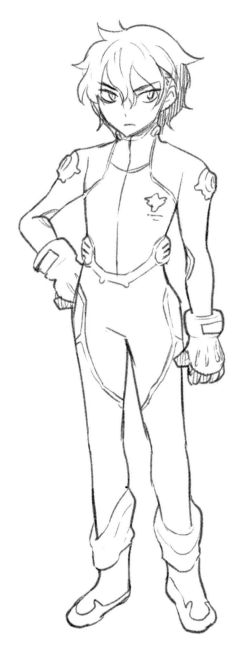

Six heads tall

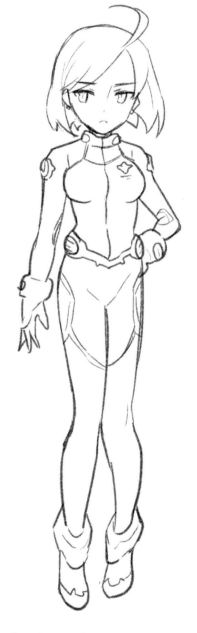

Give the hero a brooding, wounded look, with a facial expression that suggests something having happened in his past. The flying suit he's wearing is designed to look futuristic and cool.

Design her hairstyle and other attributes to have a slightly unrealistic feel to bring out the sci-fi vibe. Her suit emphasizes the lines of the body, creating a slim, chic appearance.

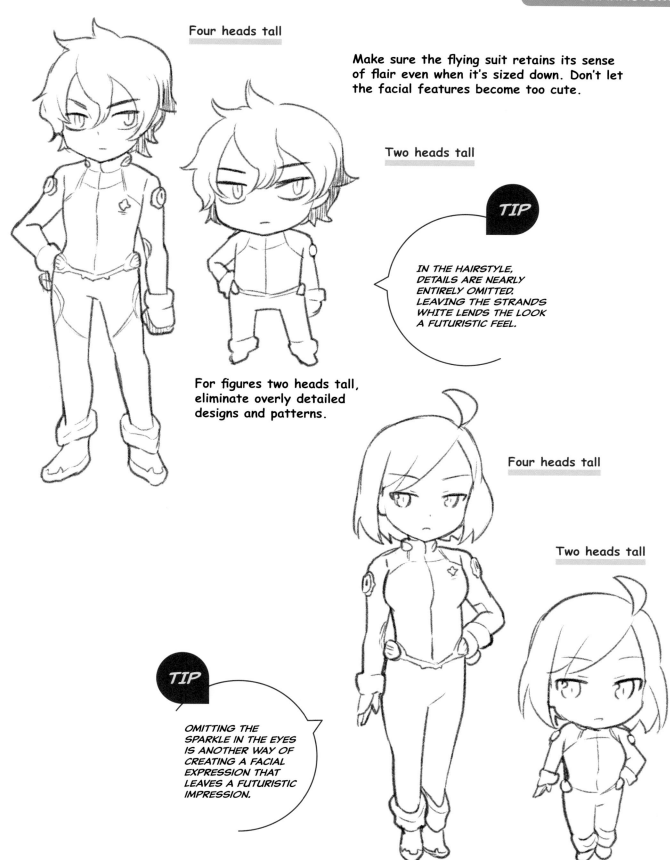

Four heads tall

Make sure the flying suit retains its sense of flair even when it's sized down. Don't let the facial features become too cute.

Two heads tall

TIP

IN THE HAIRSTYLE, DETAILS ARE NEARLY ENTIRELY OMITTED. LEAVING THE STRANDS WHITE LENDS THE LOOK A FUTURISTIC FEEL.

For figures two heads tall, eliminate overly detailed designs and patterns.

Four heads tall

Two heads tall

TIP

OMITTING THE SPARKLE IN THE EYES IS ANOTHER WAY OF CREATING A FACIAL EXPRESSION THAT LEAVES A FUTURISTIC IMPRESSION.

Shoot for a balance of sharpness and sweetness in your heroine. Make sure that the character's air of loneliness is retained.

Sub-characters

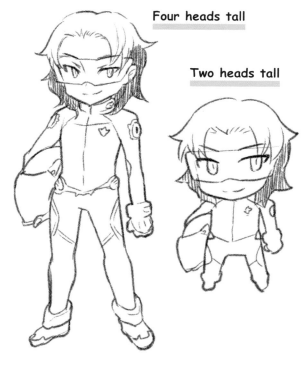

Four heads tall

Two heads tall

Flying ace

While this character resembles the protagonist, he wears a confident expression all his own, and there's a sense of power in his stance. Give him an air of casual assurance.

Flight instructor

Make this character, the reliable older-sister role, the complete opposite of the protagonist in terms of personality and appearance. She can still be a head-turner though.

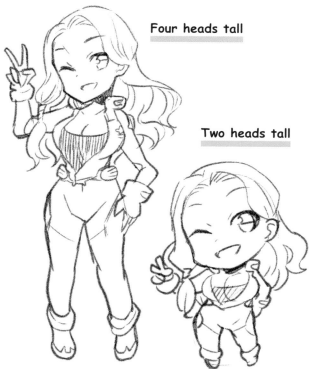

Four heads tall

Two heads tall

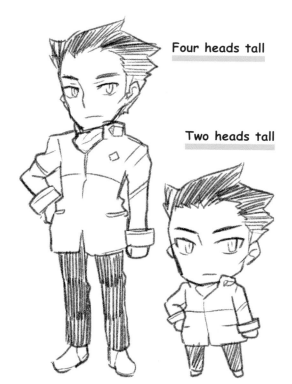

Four heads tall

Two heads tall

Commanding officer

Tailored, close-fitting garments that recall military uniforms work well here. Give the character a dignity that comes from years of experience, more than that of the protagonist.

Robot mascot

Frequently, these characters have been created in a chibi style to begin with, so rather than changing proportions, just tweak their shape and form. Adding small animals for inspiration makes these characters even more adorable.

Four heads tall

Two heads tall

Four heads tall

Two heads tall

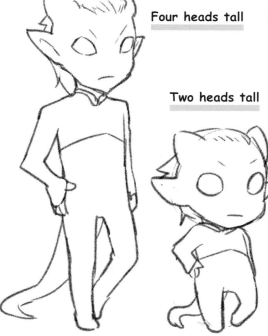

Alien

Aliens resemble intelligent life-forms because of their similarity to humans. If you want them to be perceived as enemies, make them less human-like.

The protagonist's robot

When drawing robots in the chibi style, making their hands and feet large imparts a toy-like adorability. Conversely, making them small evokes a cool, cyber vibe.

Four heads tall

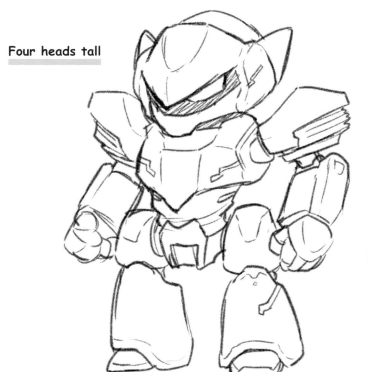

Two heads tall

Frequently occurring scenes

Battles between robots

In scenes where a robot is fighting an enemy in outer space, choose a perspective that creates a sense of momentum. Use effects such as laser beams to heighten the intensity.

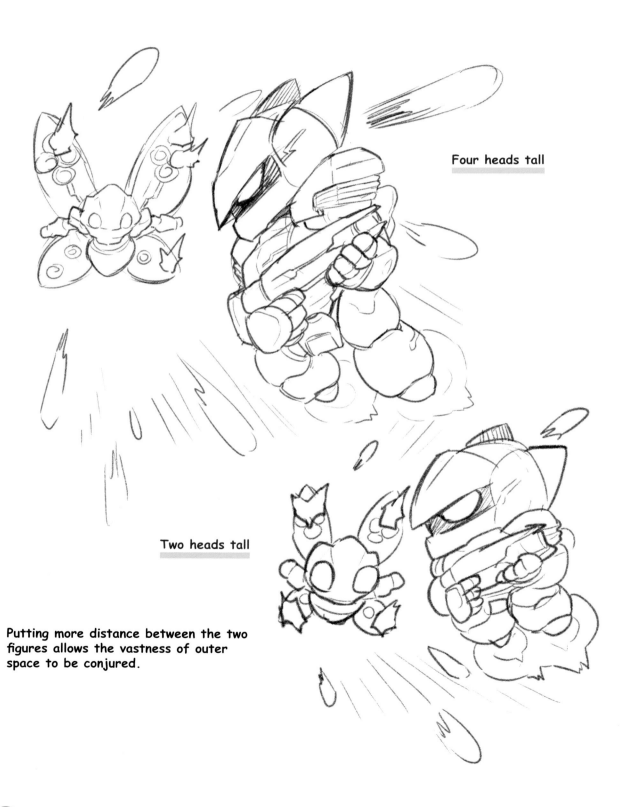

Four heads tall

Two heads tall

Putting more distance between the two figures allows the vastness of outer space to be conjured.

Landing on a planet

Rather than just a flying suit, work in a transparent helmet over the face and protective armor.

Four heads tall

Two heads tall

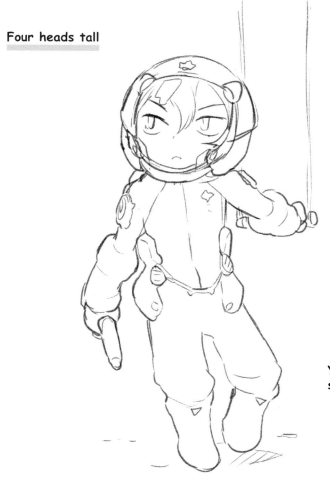

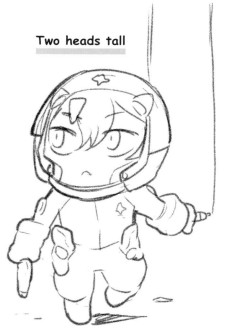

You can always turn to actual spacesuits and sportswear as good sources of reference.

Four heads tall

Repairing a robot

Here the character's regular suit is exchanged for work clothes to carry out the repair.

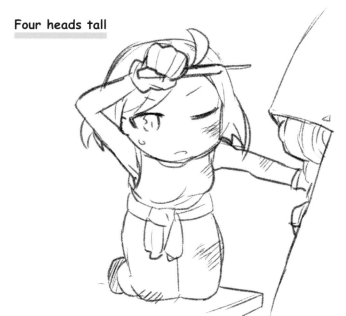

Two heads tall

At correct proportions, a figure two heads tall would not be able to wipe her brow with her hand. The fact that this physical reality doesn't need to be given consideration as you draw is part of the freedom and appeal of working in the chibi style.

CHARACTERS IN FIGHT SCENES

IT'S A BATTLE OF STRENGTH AND WILLS WHEN THESE FIGHTERS MEET. ADAPT THESE FLEXED PHYSIQUES USING THE CHIBI STYLE.

Champion Fighting characters are strong both physically and mentally, so it's important to design them to appear sturdy and robust, as if with cores of steel.

Six heads tall

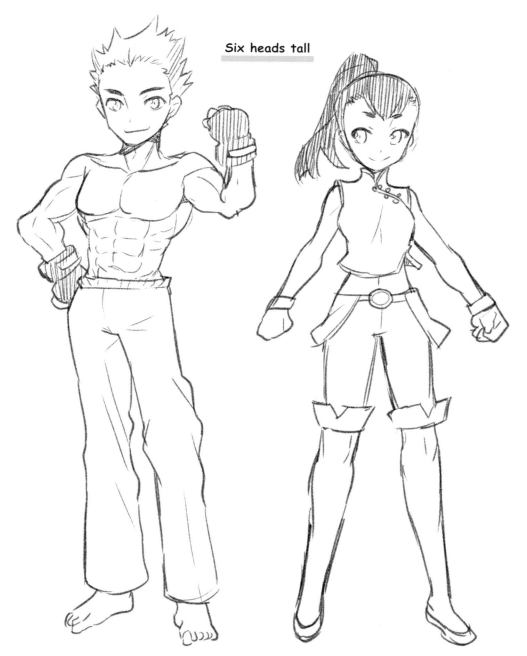

This guy is an all-around fighter. Again, the focus is on the mass of muscles.

If it's a kung fu fight you're featuring, dress the character in martial arts garb. Convey her toned but not overly muscular physique through the lines of her body.

Four heads tall

Two heads tall

When working in the chibi style, make sure not to go overboard when drawing muscles or the resulting figure will look unbalanced. The higher the ratio between the head and body, the more moderation is required.

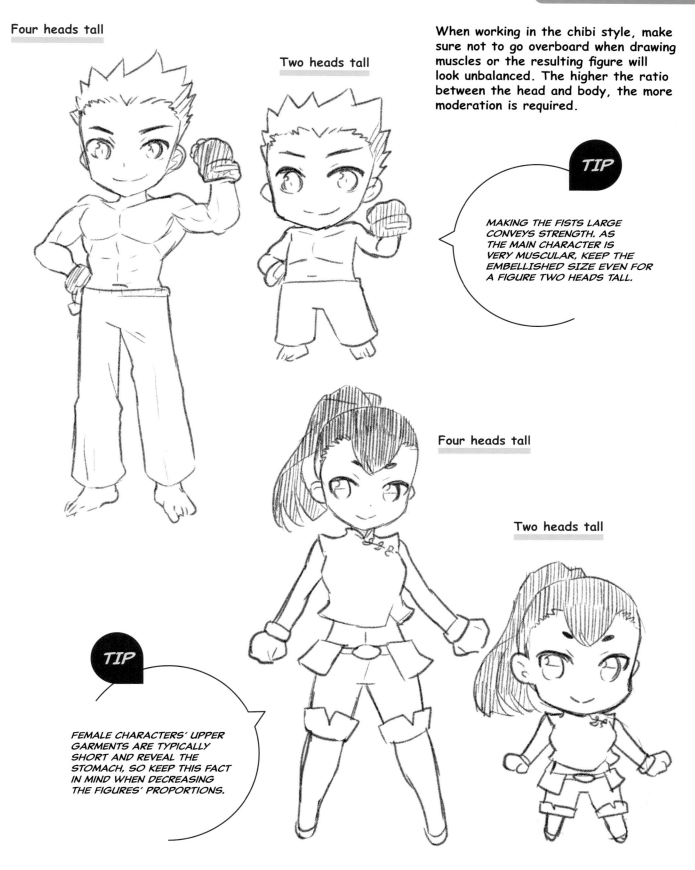

TIP

MAKING THE FISTS LARGE CONVEYS STRENGTH. AS THE MAIN CHARACTER IS VERY MUSCULAR, KEEP THE EMBELLISHED SIZE EVEN FOR A FIGURE TWO HEADS TALL.

Four heads tall

Two heads tall

TIP

FEMALE CHARACTERS' UPPER GARMENTS ARE TYPICALLY SHORT AND REVEAL THE STOMACH, SO KEEP THIS FACT IN MIND WHEN DECREASING THE FIGURES' PROPORTIONS.

Be conscious of creating an elegant, erect posture when drawing heroines. When applying the chibi style, retain this posture in the limbs. The clenched fists and stance evoke courage!

Sub-characters

Four heads tall

Two heads tall

Rival

In contrast to the hot-blooded protagonist, the rival has a cool demeanor, so bring out a sense of calm in her pose and facial expression.

Make the hair long to contrast with the silhouette of the protagonist.

Giant

Four heads tall

Emphasize the differences between the protagonist and this typically outsized character through his physique and facial expression. As he's not a particularly important character, keep his outfit and accessories simple.

Two heads tall

Four heads tall

Reversing the pupil and iris yields an oddly evil look.

Two heads tall

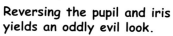

Party girl

This sophisticate seems an unlikely fighter, as signaled through her slim physique, hairstyle, clothing and cheerful expression.

Hermit

Sketch in shaggy eyebrows that cover the eyes, and add a long beard to suggest the hermit's detachment and isolation from the everyday world. In a serious scene, he can suddenly transform into a muscleman or take on some other completely different form.

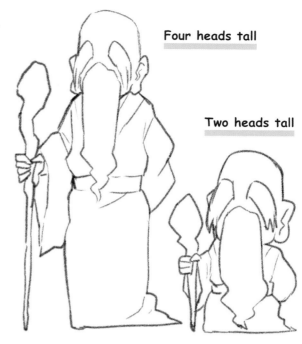

Four heads tall

Two heads tall

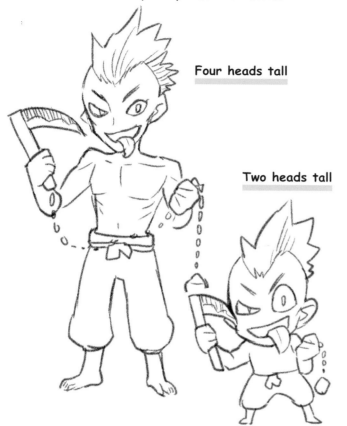

Four heads tall

Two heads tall

Enemy

In contrast to the main characters who fight with their fists, this evil one uses weapons. Give him a mean, surly expression and a wild unkempt hairstyle to heighten his sense of villainy.

Rich person

A sumptuous coat and a rounded belly convey a sense of wealth and ease. While the porcine nose and ears create a slightly comical effect, this character should also be somewhat sinister.

Aim to create the image of a filthy rich landowner.

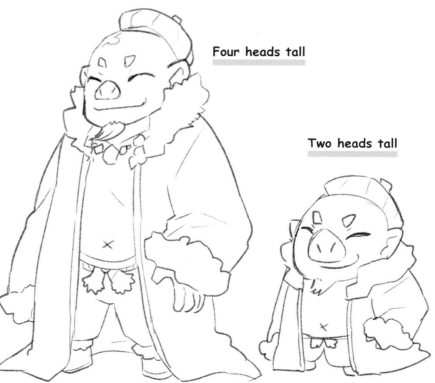

Four heads tall

Two heads tall

Frequently occurring scenes

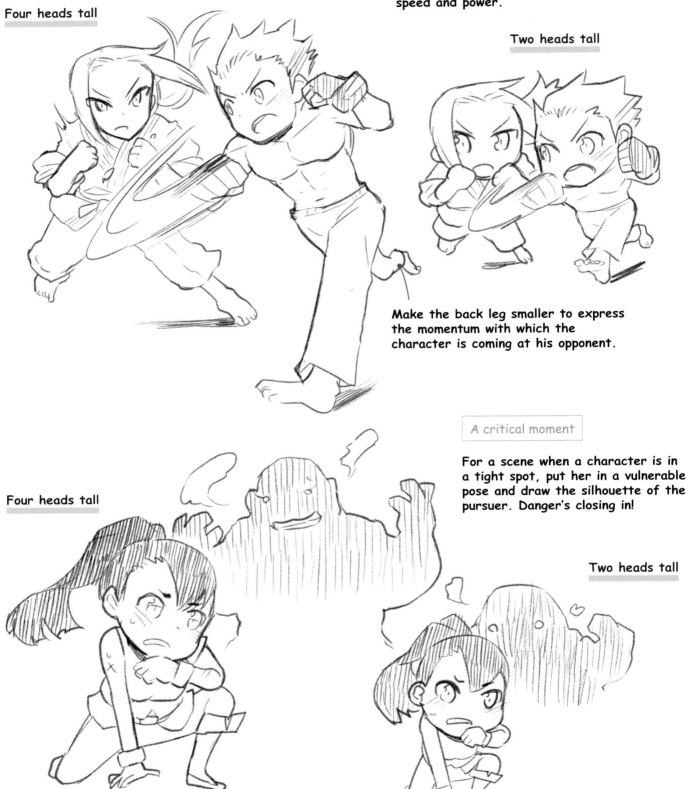

Fight scenes

These scenes showcase your characters' physicality and skill. Drawing the after images of a flying fist injects a sense of speed and power.

Four heads tall

Two heads tall

Make the back leg smaller to express the momentum with which the character is coming at his opponent.

A critical moment

For a scene when a character is in a tight spot, put her in a vulnerable pose and draw the silhouette of the pursuer. Danger's closing in!

Four heads tall

Two heads tall

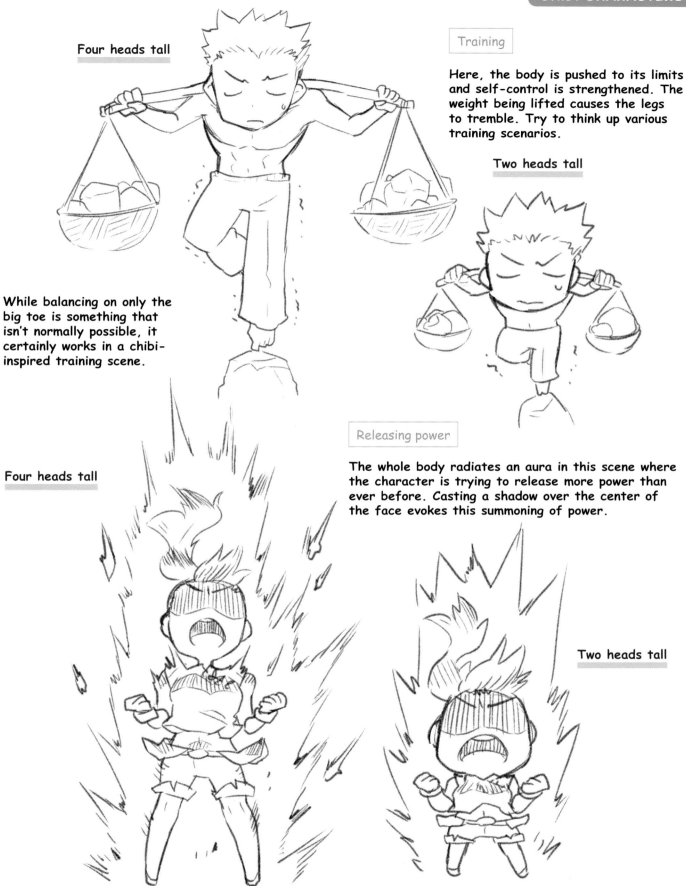

Four heads tall

Training

Here, the body is pushed to its limits and self-control is strengthened. The weight being lifted causes the legs to tremble. Try to think up various training scenarios.

Two heads tall

While balancing on only the big toe is something that isn't normally possible, it certainly works in a chibi-inspired training scene.

Releasing power

Four heads tall

The whole body radiates an aura in this scene where the character is trying to release more power than ever before. Casting a shadow over the center of the face evokes this summoning of power.

Two heads tall

Depending on how you design the aura surrounding the character, various types of power and strength can be conjured. For an evil character, create a sinister, threatening aura.

VARIOUS COSTUMES

FROM FANTASY FIGURES TO FOLKS WITH REAL-LIFE OCCUPATIONS, THERE'S ENDLESS VARIETY IN THE CLOTHING AND OUTFITS YOU CAN CREATE.

Pop group

Four heads tall

The key point when creating outfits for female pop groups is a sense of unity. While the outfits share a uniform look, each should be slightly different to reflect the members' distinct personalities.

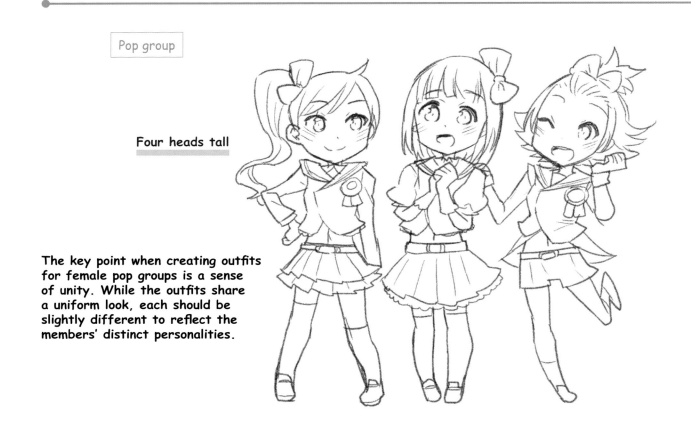

Two heads tall

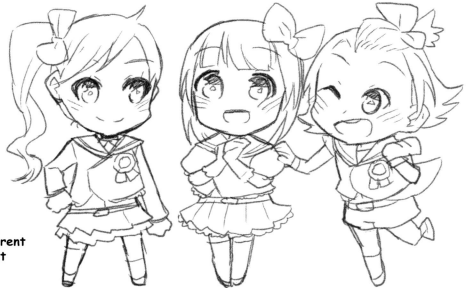

As with their ensembles, gives the musicians different poses to further highlight their individual qualities.

Glam-rock band

Rather than using bold poses, depict them standing confidently together to convey their cool vibe.

Four heads tall

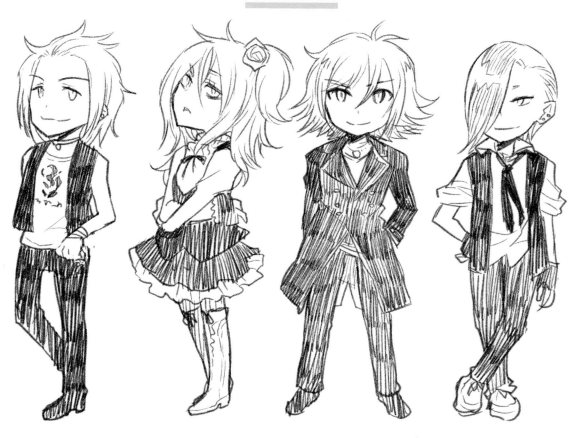

Two heads tall

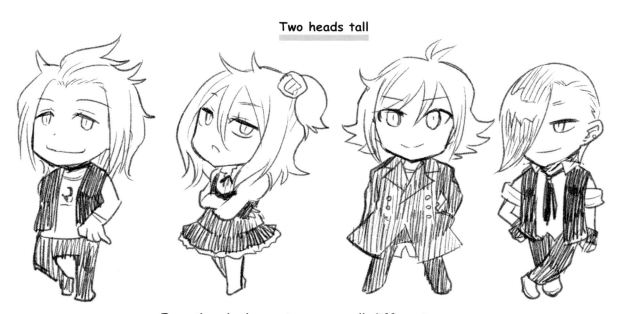

Even though the costumes are all different, you can use color, tone and contrast to create a sense of unity.

Four heads tall

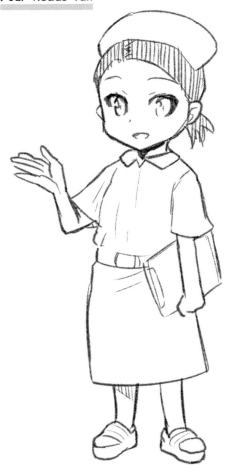

Two heads tall

Nurse

Incorporate realism into the details of the nurse's hairstyle, shoes and cap, while at the same time applying the chibi style.

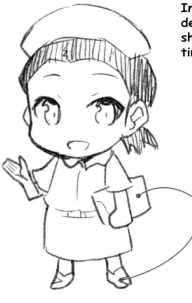

Don't draw in too much detail in the shoes and chart, focusing on the silhouette instead.

Four heads tall

Adding gray hair and other signs of age can also make it easier to convey that the character's a doctor.

Two heads tall

Doctor

As with a nurse, a clean, crisp white uniform makes for a realistic-looking doctor. Add a stethoscope and other small medical-related items.

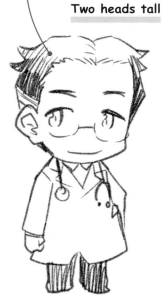

Four heads tall

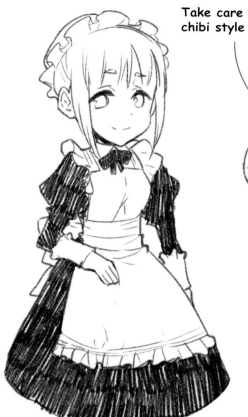

Take care when applying chibi style to the frill.

Two heads tall

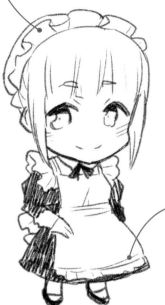

Maid

This maid is wearing a traditional cap and uniform. Changing the apron and the length of the skirt turns her into a cute, contemporary figure right out of a cafe.

Simplify the frills and volume in the hem to suit the figure's proportions.

Four heads tall

Two heads tall

Butler

Portray the butler with a stony demeanor and even stiffer posture than the maid's for a realistic effect. A tailcoat helps to complete the look.

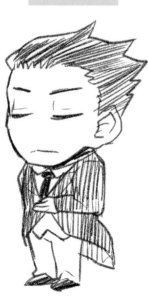

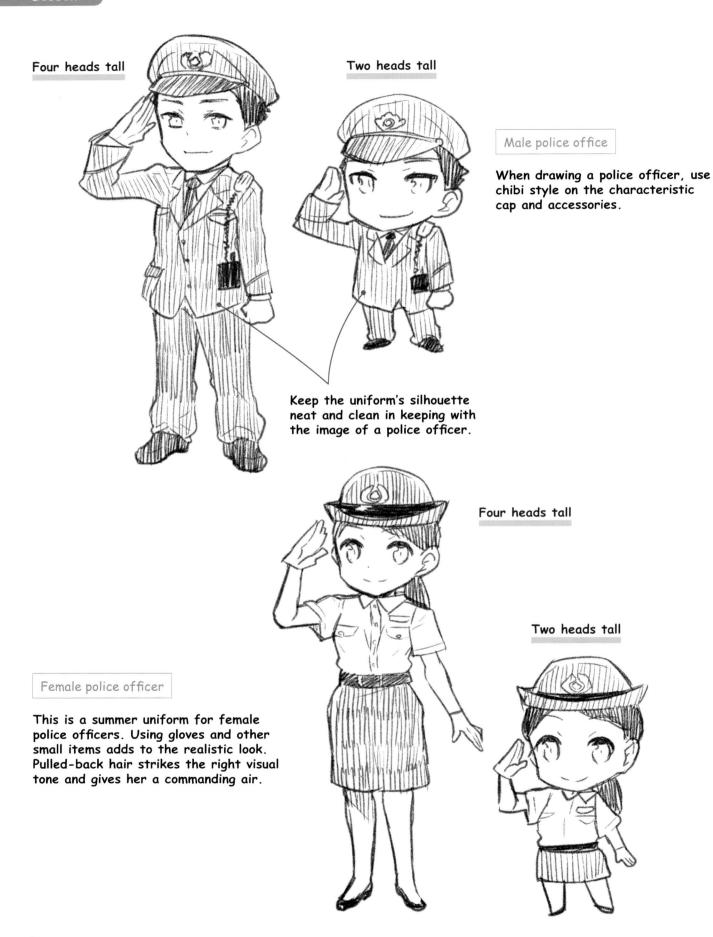

Four heads tall

Two heads tall

Male police office

When drawing a police officer, use chibi style on the characteristic cap and accessories.

Keep the uniform's silhouette neat and clean in keeping with the image of a police officer.

Four heads tall

Two heads tall

Female police officer

This is a summer uniform for female police officers. Using gloves and other small items adds to the realistic look. Pulled-back hair strikes the right visual tone and gives her a commanding air.

Four heads tall

Two heads tall

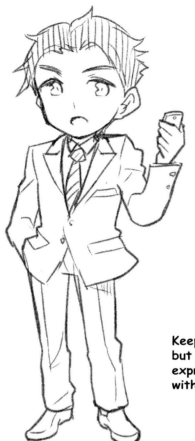

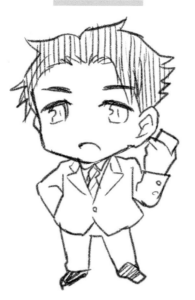

Businessman

Use a tie and a cellphone to suggest a suited salaryman. For an even more serious buttoned-down look, draw in glasses and slicked-back hair.

Keep the suit blandly conventional, but use the hairstyle and facial expression to infuse the character with an active, brisk manner.

Four heads tall

Two heads tall

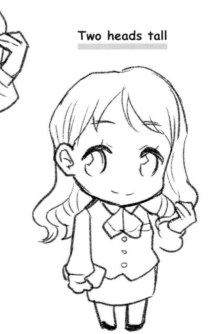

Businesswoman

A blouse, waistcoat and fitted skirt means she's headed to the office. Simply dressing the character in these pieces suggests the role, so it's fine to keep the hair and other aspects of the appearance low key and attractive.

Four heads tall

Two heads tall

Male military officer

The uniform recalls Europe in the Napoleonic era, using French military attire as inspiration.

In the fantasy realm, long flowing locks have become a standard marker of a musketeer or charming rogue.

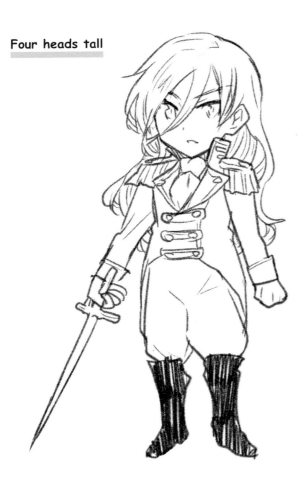

Four heads tall

Two heads tall

Female military officer

Give her posture solidity and weight, but make the line of the body feminine to soften the overall look.

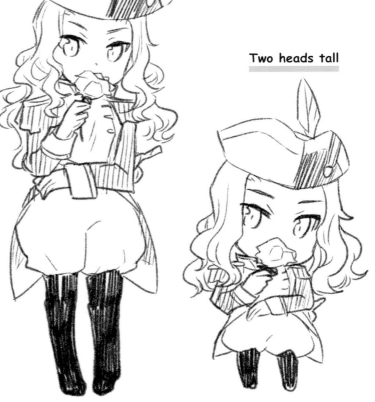

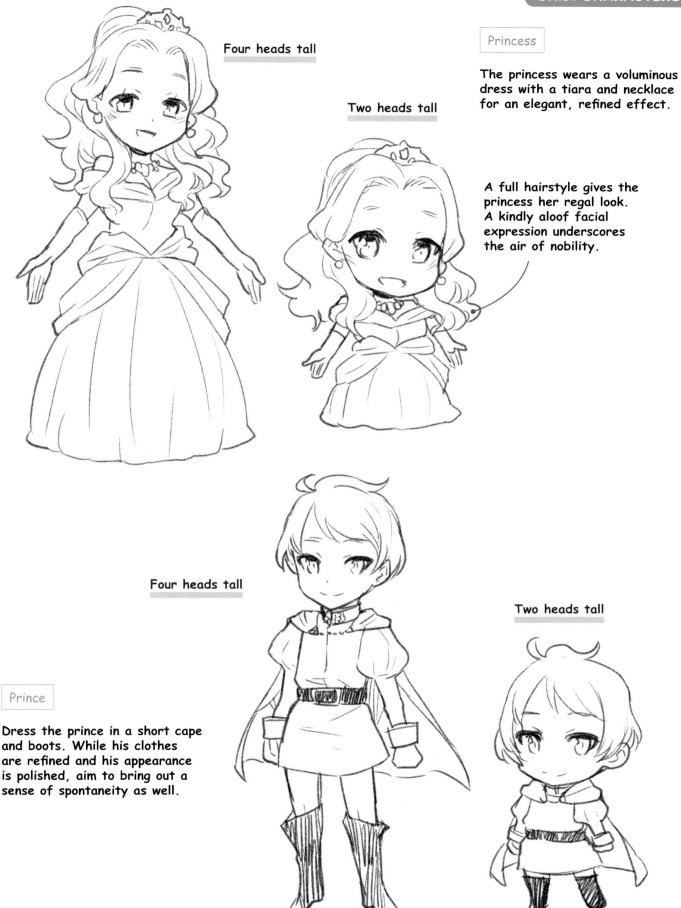

Four heads tall

Two heads tall

The princess wears a voluminous dress with a tiara and necklace for an elegant, refined effect.

A full hairstyle gives the princess her regal look. A kindly aloof facial expression underscores the air of nobility.

Four heads tall

Two heads tall

Prince

Dress the prince in a short cape and boots. While his clothes are refined and his appearance is polished, aim to bring out a sense of spontaneity as well.

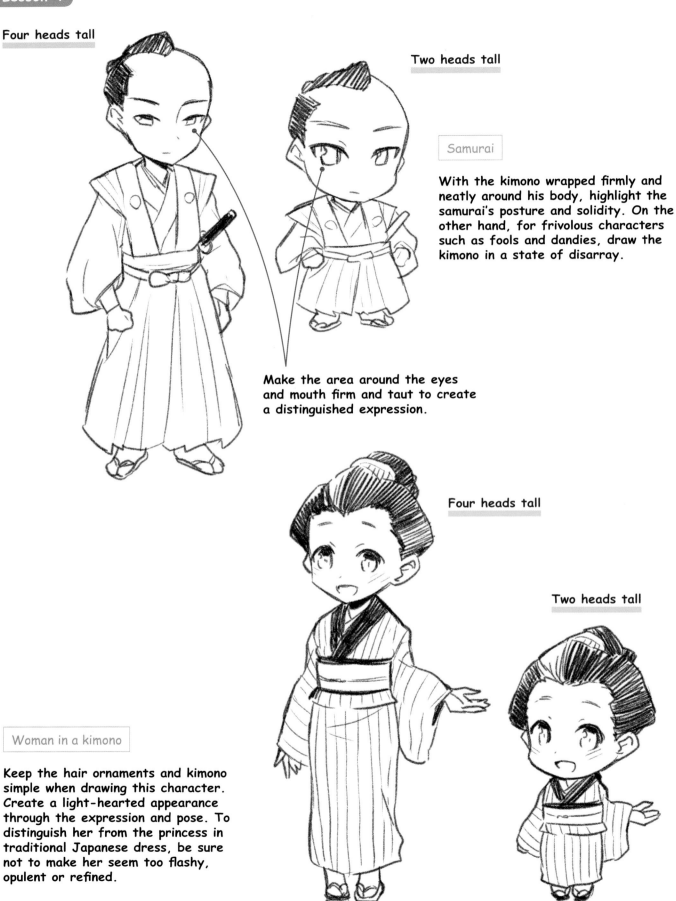

Four heads tall

Two heads tall

Samurai

With the kimono wrapped firmly and neatly around his body, highlight the samurai's posture and solidity. On the other hand, for frivolous characters such as fools and dandies, draw the kimono in a state of disarray.

Make the area around the eyes and mouth firm and taut to create a distinguished expression.

Four heads tall

Two heads tall

Woman in a kimono

Keep the hair ornaments and kimono simple when drawing this character. Create a light-hearted appearance through the expression and pose. To distinguish her from the princess in traditional Japanese dress, be sure not to make her seem too flashy, opulent or refined.

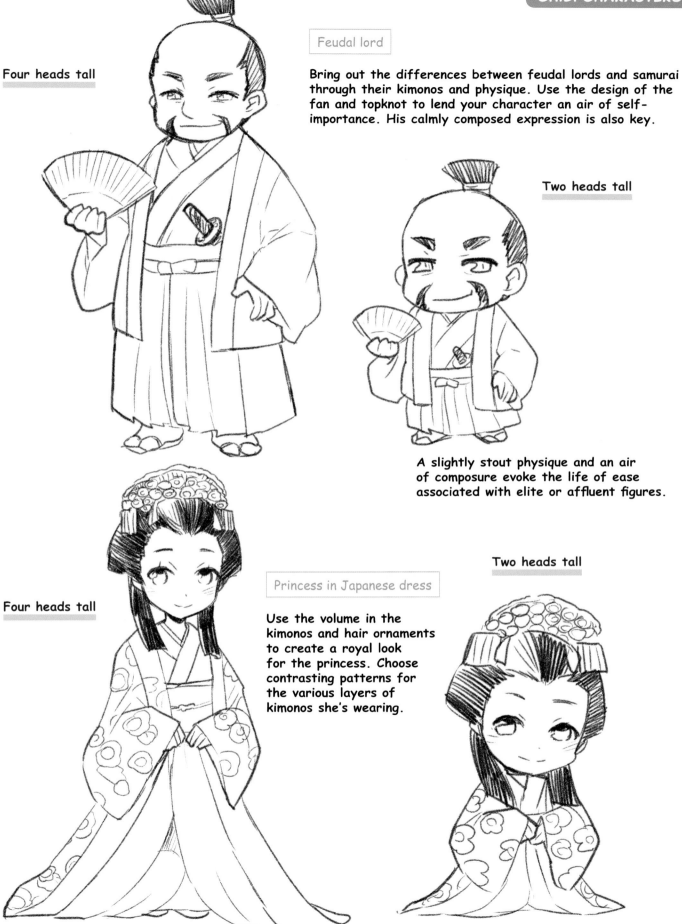

Four heads tall

Feudal lord

Bring out the differences between feudal lords and samurai through their kimonos and physique. Use the design of the fan and topknot to lend your character an air of self-importance. His calmly composed expression is also key.

Two heads tall

A slightly stout physique and an air of composure evoke the life of ease associated with elite or affluent figures.

Four heads tall

Princess in Japanese dress

Use the volume in the kimonos and hair ornaments to create a royal look for the princess. Choose contrasting patterns for the various layers of kimonos she's wearing.

Two heads tall

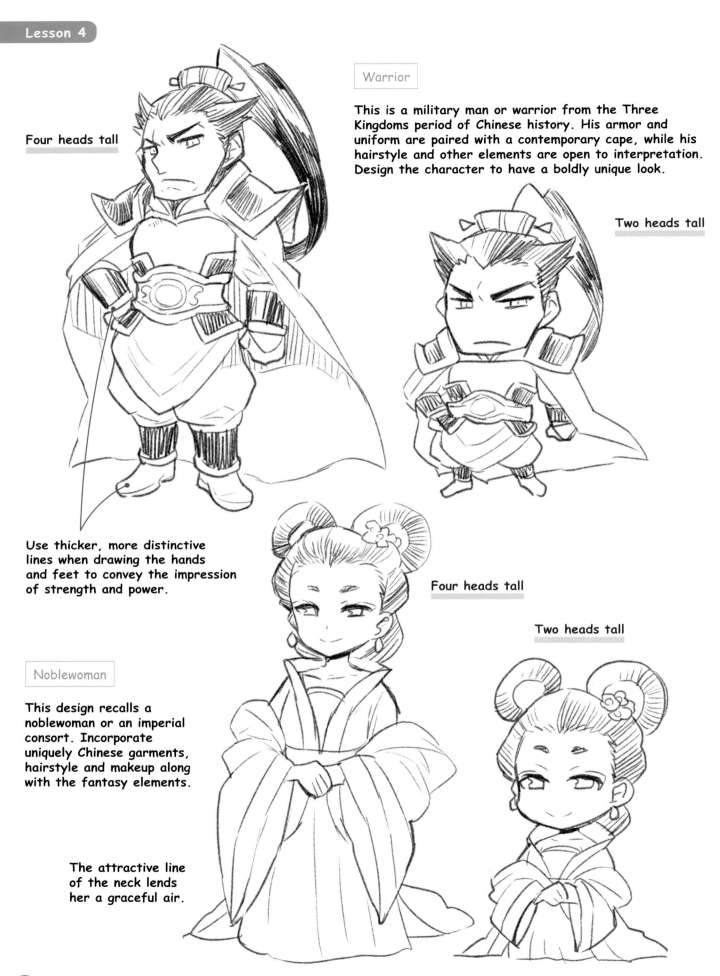

Four heads tall

Warrior

This is a military man or warrior from the Three Kingdoms period of Chinese history. His armor and uniform are paired with a contemporary cape, while his hairstyle and other elements are open to interpretation. Design the character to have a boldly unique look.

Two heads tall

Use thicker, more distinctive lines when drawing the hands and feet to convey the impression of strength and power.

Four heads tall

Two heads tall

Noblewoman

This design recalls a noblewoman or an imperial consort. Incorporate uniquely Chinese garments, hairstyle and makeup along with the fantasy elements.

The attractive line of the neck lends her a graceful air.

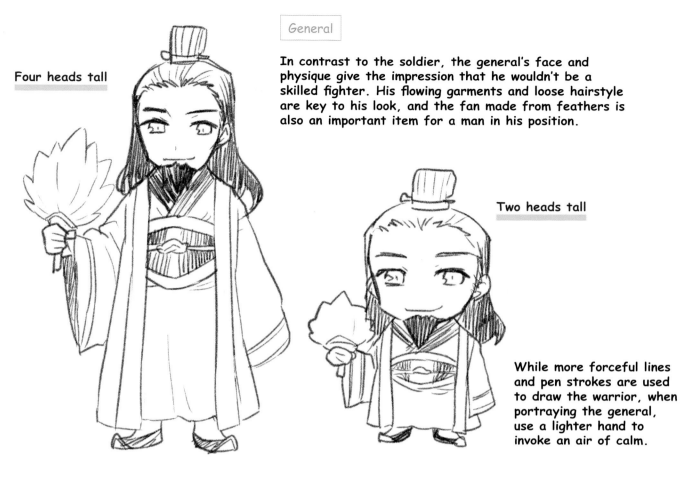

Four heads tall

General

In contrast to the soldier, the general's face and physique give the impression that he wouldn't be a skilled fighter. His flowing garments and loose hairstyle are key to his look, and the fan made from feathers is also an important item for a man in his position.

Two heads tall

While more forceful lines and pen strokes are used to draw the warrior, when portraying the general, use a lighter hand to invoke an air of calm.

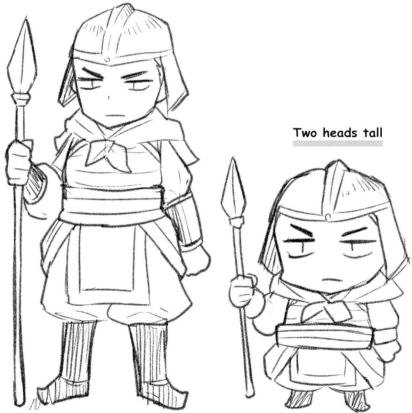

Four heads tall

Two heads tall

Foot soldier

As a soldier who fights on the battleground, this character's dress is much plainer than the military officer's. His face, too, should be unremarkable, to show that he's a minor figure. These kinds of supporting characters are valuable as background elements to fill in the stories you tell.

Four heads tall

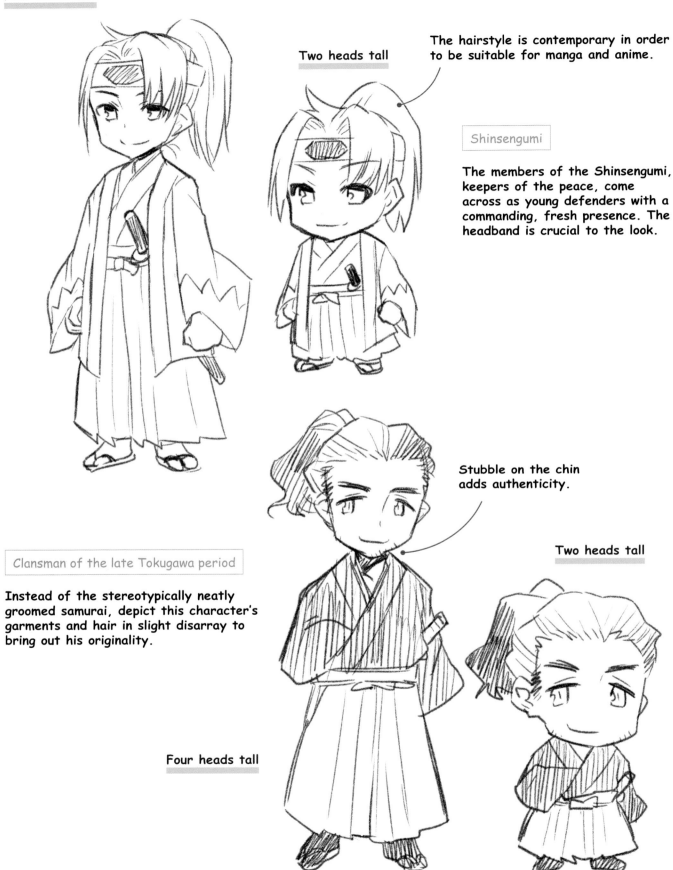

Two heads tall

The hairstyle is contemporary in order to be suitable for manga and anime.

Shinsengumi

The members of the Shinsengumi, keepers of the peace, come across as young defenders with a commanding, fresh presence. The headband is crucial to the look.

Stubble on the chin adds authenticity.

Two heads tall

Clansman of the late Tokugawa period

Instead of the stereotypically neatly groomed samurai, depict this character's garments and hair in slight disarray to bring out his originality.

Four heads tall

Four heads tall

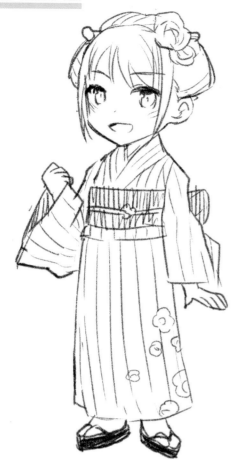

Two heads tall

Stylish young woman

This character is a fashionable woman from the time just before the Meiji period. Pay particular attention to her hairstyle and the way her obi is fastened. Prioritize cuteness over historical accuracy.

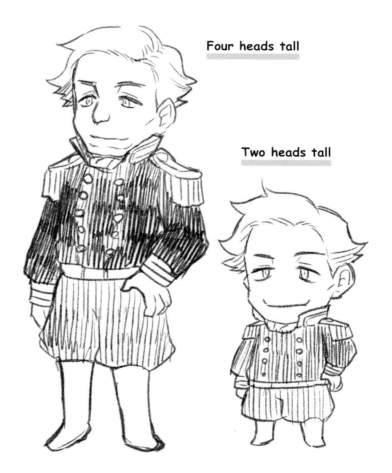

Four heads tall

Two heads tall

Foreigner

Give these figures chiseled, well-defined facial features. When drawing the character two heads tall, pay particular attention to the physique.

PUTTING CHIBI CHARACTERS TO USE

CHIBI CHARACTERS CAN BE THE STARS NOT ONLY OF YOUR ILLUSTRATIONS,
BUT THEY CAN DRESS UP ALL KINDS OF ITEMS.

Key holder

Try snapping one onto your bag. A chibi character on your keyring makes for a great look!

Business card

For an unexpected look, why not add chibi characters to business cards? The eye-catching card will leave an impression or serve as a conversation starter when you hand one over.

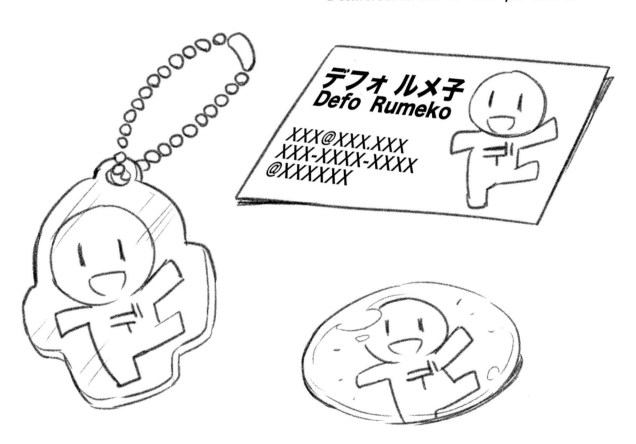

デフォルメ子
Defo Rumeko

XXX@XXX.XXX
XXX-XXXX-XXXX
@XXXXXX

There are lots of other practical applications for chibi characters. Try drawing them on various items to personalize your possessions.

Badge

Pin a cute chibi character to a bag or your clothes. Of course they're adorable, but they're also stylish.

CHIBI IN COLOR

BASIC COLOR APPLICATION

ONCE YOU ARE ABLE TO DRAW CHARACTERS FREELY, TRY COLORING THEM IN. HERE, WE LOOK AT CLIP STUDIO PAINT EX, TO BETTER UNDERSTAND THE COLORING PROCESS.

| Basic color application process | First, we'll look at applying color to individual characters, both at two heads tall and four heads tall. |

SOFTWARE USED Clip Studio Paint Ex **USER PLATFORM** MAC OS X

1 MAKE A SKETCH

Sketch the character, checking the proportions as you go. Here, in order to carry out basic color application, we'll compare proportions by working on the same character at two heads tall and four heads tall.

✅ **Check !**

Make the pose the same so that when you compare the characters, the differences are obvious.

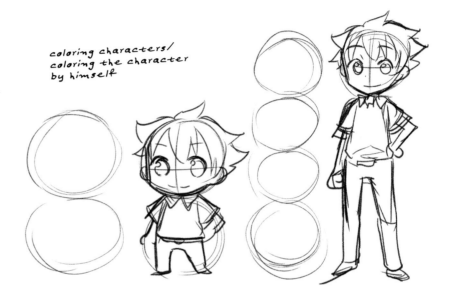

coloring characters/
coloring the character
by himself

2 MAKE A CLEAN COPY

Make the drawing using the G Pen or round pen tool at a thickness of 0.6-1mm.

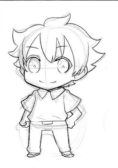

TIP

When drawing in pen for a figure two heads tall, use a slightly firm, thick line. This emphasizes the character's chibi elements.

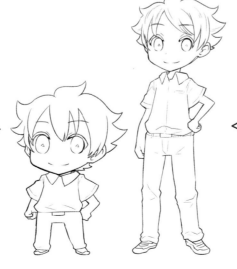

TIP

Compared with the character two heads tall, more detail is used on this character, such as in the hair and the wrinkles in the clothing. Use both strong and wispier lines to form an image that has dimension, taking care to make the outline thick and other lines more fine.

3 CORRECT THE LINE DRAWING

Make corrections to the fine details such as the hair on the character two heads tall by comparing it with the taller character.

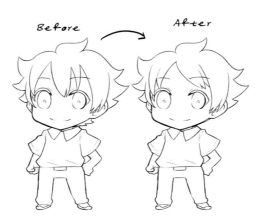
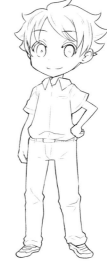

Before After

✔ Check !

Work that's tedious when done by hand can be easily performed when working with digital tools.

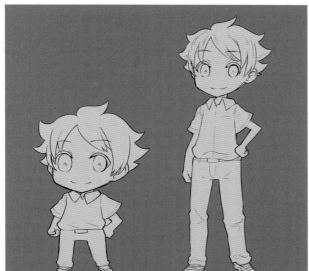

4 PREPARE TO APPLY COLOR

Lay monochrome color over the areas you wish to color in. This process also has the result of safeguarding the transparent areas of the layer (such as the areas around the figure), preventing color from going outside the lines.

TIP

Using gray for the background allows the depth of shadow to be easily adjusted along with preventing tones being affected by backgrounds that are too bright or dark.

5 APPLY BASE COLOR

Use the bucket (fill with color) tool or pen tool to color various parts of the characters. At this stage, compare shades in detail as you apply color. At the same time, make fine corrections in pen if you notice mistakes when coloring and reapply color if necessary.

✔ Check !

Fix mistakes made when drawing or applying color as soon as you notice them.

TIP

Don't layer each part of the body, but use one layer divided into different colors. Applying color to both the differently proportioned figures at the same time allows the same shades to be achieved.

6 ADD SHADOW

Create a new layer and place shadow over the characters. Note that applying shadow is different depending on the characters' proportions. Chibi style has been used to strong effect in the shadow on the character two heads tall as well as on the figure itself. The lines that make up this figure are simple, so to highlight this, minimal shadow is used. For the character four heads tall, increase the amount of detail.

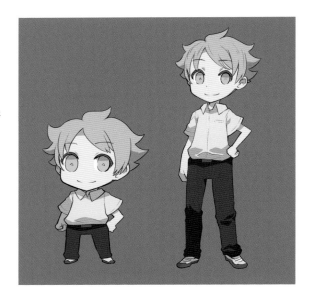

TIP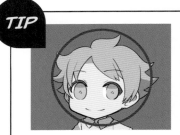

Use the greatest amount of shadow on the parts of the face, decreasing detail as you work toward the extremities. For the character two heads tall, there's some shadow on the face but hardly any on the hands and feet. Doing this guides the viewer's gaze to the area with the most information and detail: in other words, to the face.

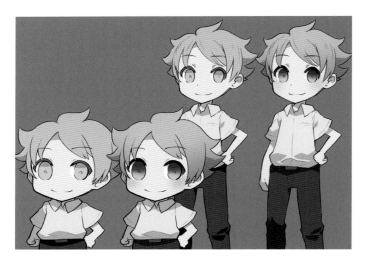

7 INCORPORATE GRADATION

The application of shadow is complete, but if left at this point, the image has no depth, so gradation is added, focusing on four areas of the face: the eyes, upper eyelashes, hair and cheeks.

✓ Check !

Adding gradation brings out depth. Comparing the characters before and after adding gradation, you'll notice how it enhances their appearance. Use the gradation tool and airbrush to layer color.

8 ADD HIGHLIGHTS

Draw in highlights. For the highlights in the eyes, don't simply use white, but add color and then apply white over the top. This significantly heightens the expression in the eyes.

✓ Check !

For the character two heads tall, use less layered highlights in the hair.

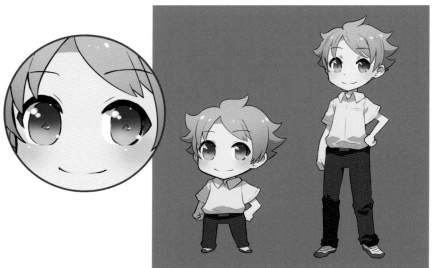

9 ADD COLOR TRACE

This step involves adding color to the line drawing that was done purely in black. Create a new layer over the line drawing layer and use the clipping mask setting to add color to bright areas with the airbrush or pen tool. The mask prevents parts other than the drawing from being affected in lower layers.

✔ Check !

Placing color on bright areas—where there's no shadow—brings out subtle dimension.

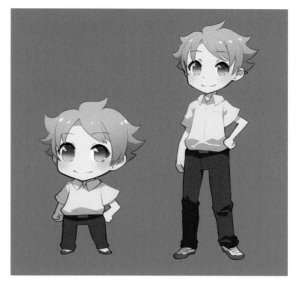

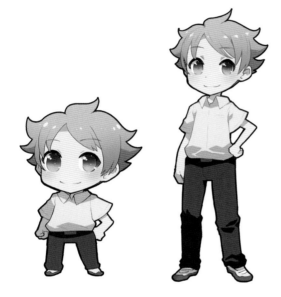

10 ADD AN OUTLINE

Add a line around the figure. Use "outline" in the layer option function to easily apply the line. This makes the character stand out and highlights the unique characteristics of the figure.

11 ADD BACKGROUND

Complete the drawing by adding a simple background treatment.

This is basically the process that I use to add color to characters. Each step is easy, but they all come together to create charming characters, so definitely try it for yourself.

FINISHED!

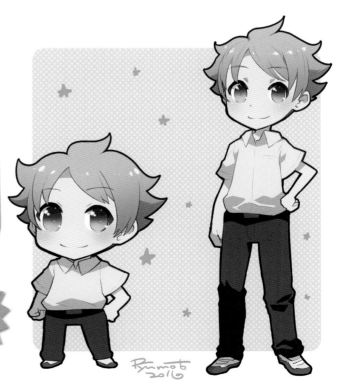

CREATING A COVER, POSTER OR DISPLAY

WHEN IT COMES TO PRODUCING LARGER-SCALE WORK, IT'S NOT JUST ABOUT APPLYING COLOR. ADDING DIMENSION AND SHADING INSTANTLY IMPROVE AND ENHANCE A DRAWING!

The coloring and layout process

1 DRAW A ROUGH SKETCH

This shows the creation process for the cover and frontispiece published on page 9. The composition is for the frontispiece on page. As it involved drawing several characters at once, I used the characters from chapters 3 and 4 and positioned them in lively poses.

✅ Check !

Here, we'll proceed with the work referring to the characters two heads tall in front as "mini characters," while those four heads tall at the back are called "main characters."

2 MAKE ROUGH DRAWINGS OF THE MINI CHARACTERS

Roughly draw the mini characters. Make sure to pose them to reflect each character's unique qualities.

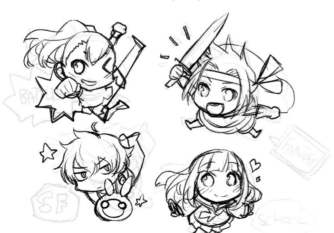

TIP

When drawing multiple characters at the same time, refer to the rough sketches so as not to make mistakes, but use the layers to make actual corrections.

③ MAKE ROUGH DRAWINGS OF THE MAIN CHARACTERS

As for the mini characters, check the rough sketches as you draw in the main characters. I've used cute, dynamic poses for these two.

✔ **Check !**

In the rough sketch, the feet are not visible, but in order to make the layouts easier, I've drawn the entire bodies of the characters here.

④ MAKE A CLEAN COPY OF THE MAIN CHARACTERS

Draw a clean copy of the main characters. Previously, a pen tool was used for the pen sections, but use a pencil tool this time. Using a pencil tool to make a clean copy allows you to create a drawing with a soft, analogue quality to it.

TIP

When making the clean copy, correct fine details—such as the girl's skirt flipping up to create a sense of movement—by hand.

✔ **Check !**

By comparing the red sketch lines and the black clean copy lines, you'll see how the drawing has been corrected.

⑤ MAKE A CLEAN COPY OF THE MINI CHARACTERS

Use the pen tool to make a clean copy of the mini characters.

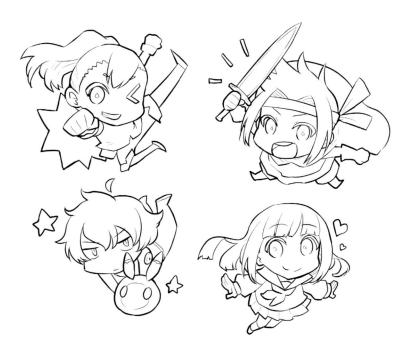

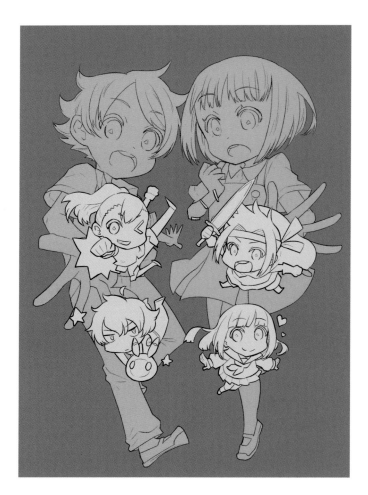

⑥ PREPARE TO APPLY COLOR

Prepare the main and mini characters so that color can be roughly applied. Doing things properly at this stage makes the steps that follow a lot easier.

✅ Check !

As with step 4 on page 131, make the background gray. This makes selecting colors and adjusting shadows easier.

7 APPLY BASE COLOR

Apply base color to the main and mini characters using the pen and bucket tools.

✅ **Check !**

If you discover a mistake in the line drawing, carefully correct it at this stage.

8 APPLY SHADOW

Apply shadow to the main characters. Create a new layer and use the multiplication function in layer effects to paint in shadow color. Do this carefully, paying attention to detail.

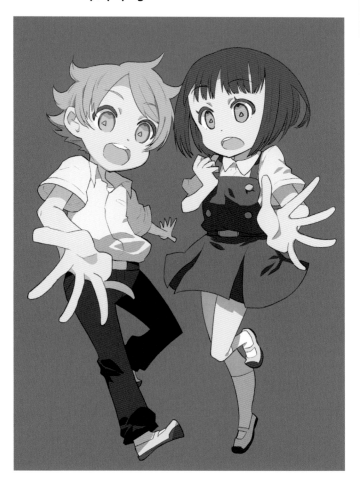

✅ **Check !**

Add shadows carefully to the parts where the mini characters cover the main characters, so that if there is a change to the design, it's not difficult to fix things.

TIP

Add shadows to the mini characters also. Basically, for the mini characters, don't add too much shadow in too many places, but keep things clean and streamlined.

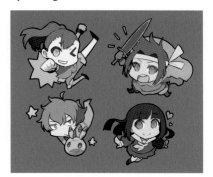

9 ADD GRADATION

Add gradation to the main characters. The reason gradation is added to the main characters first is that they're larger than the mini characters and so have a greater presence in the work as a whole.

TIP

Gradation has been added to the hair, eyes, upper lashes and cheeks along with the skirt or pants in order to create a sense of dimension. Use a slightly orange-toned pink on the cheeks to convey a healthy appearance.

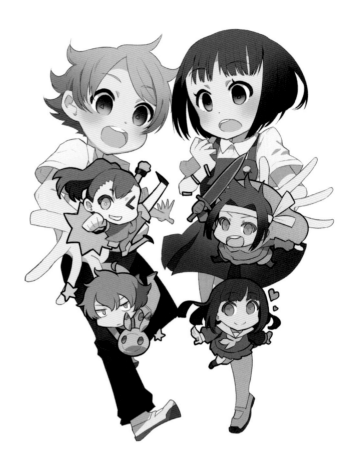

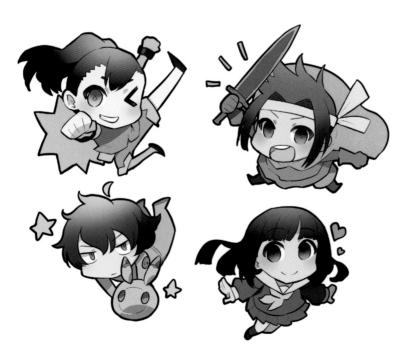

10 ADD GRADATION TO THE MINI CHARACTERS

Give the mini characters the gradation treatment too. The smaller the characters, the less fussy detail is needed. In order to achieve a clean overall impression, don't add too much gradation.

11 ADD BACKGROUND AND ROUGHLY ARRANGE THE CHARACTERS

From this point, the main and mini characters are combined, and the work needs to be viewed as a whole in order to be completed. I've added pink outlines to the main characters and am trying to convey the space and depth between the mini characters in front.

✔ Check !

Create the design elements to be used in the background and place them in position to consider how they'll fit in with the piece as you work on it.

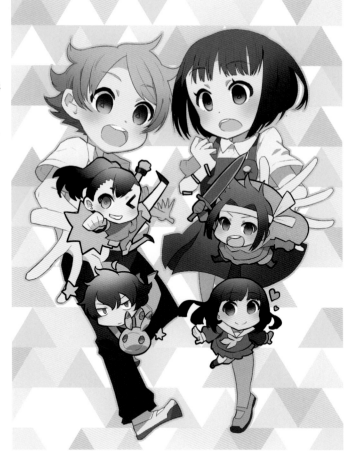

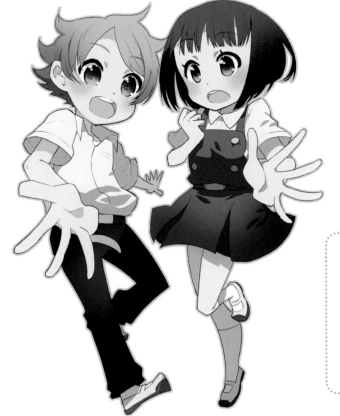

12 ADD HIGHLIGHTS

Add highlights to the eyes and cheeks. As explained in the section about basic application of color (page 132), use highlights with color added to them.

✔ Check !

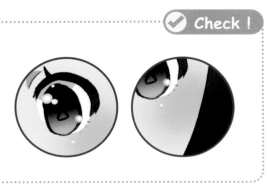

⓭ ADD DEFINITION IN THE EYES

Add a layer to the main characters' eyes and use tools such as the airbrush to create sparkle.

TIP

Use the various layer effects such as "screen," "overlay" and "addition (radiance)."

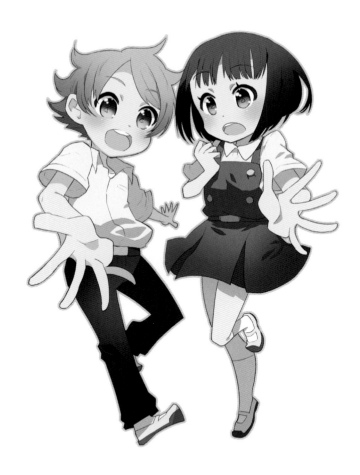

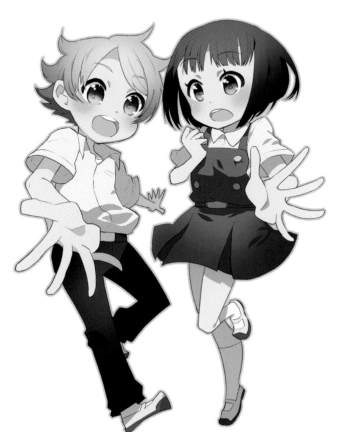

⓮ APPLY ADDITIONAL TREATMENTS TO THE HAIR

Make the main characters' hair appear slightly more dimensional. Here, the airbrush has been used to add brightness in a halo shape, with the layer effect used to infuse a soft shine.

15 APPLY HIGHLIGHTS TO THE MINI CHARACTERS

Add highlights to the mini characters too. The sci-fi character at the lower left isn't particularly lively, so exercise moderation when adding highlights.

✅ **Check !**

Alter the application of highlights to suit the character's idiosyncrasies.

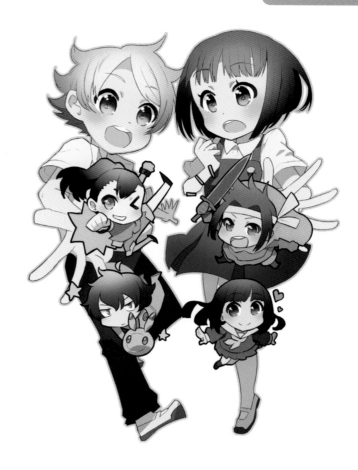

Lots of highlights

Moderate highlights

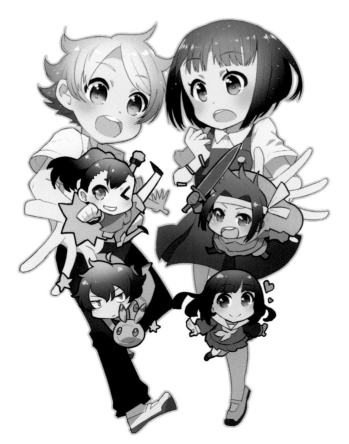

16 ADD HIGHLIGHTS TO THE HAIR

Add highlights to all the characters' hair. For the mini characters, keep highlights minimal and use them only where strictly necessary.

✅ **Check !**

For the main characters, add plenty of highlights in fine detail.

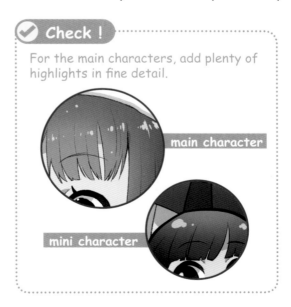

main character

mini character

17 ADD COLOR TRACE

Add color trace to the line drawings of all the characters. Aim for a soft, fuzzy feel using the pencil effect for the main characters and use the pen tool for the mini characters to add minimal color trace for a defined, clear look.

✅ Check !

Using color trace allows outlines to blend naturally.

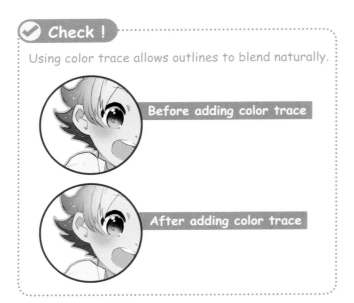

Before adding color trace

After adding color trace

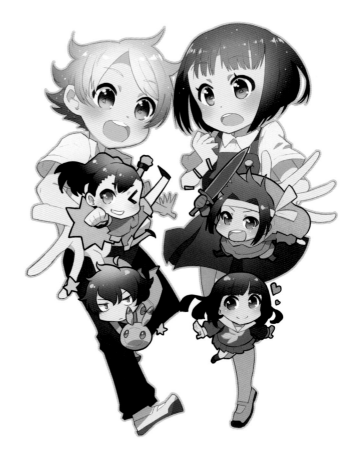

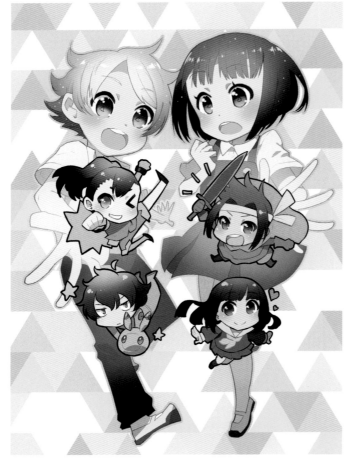

18 ADD A NEW LAYER

Create a new layer between the mini and main characters and after switching to "screen" mode, use the airbrush to roughly apply color. This makes the different depths of the main and mini characters stand out.

19 SOFTEN THE OUTLINES

Add outlines to the mini characters in colors suited to their personalities. This immediately creates a pop vibe.

Close Up!

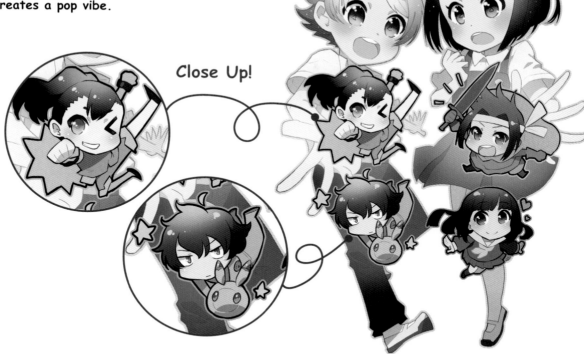

20 ADD A BACKGROUND

Finally, add a design to the background and position it to complete the work!

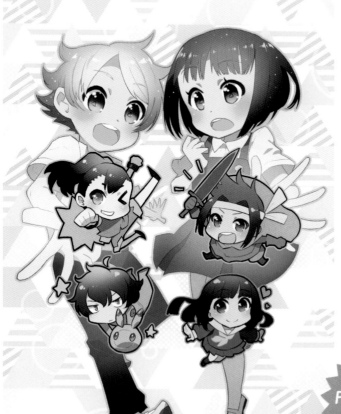

Now the work is finished! If you'd like to see it in a larger size, go back to page 9 and take a look. The aspects such as color application or adding shadows that you probably only glanced over before should be crystal clear now that you understand the drawing process!

FINISHED!

Published by Tuttle Publishing, an imprint of
Periplus Editions (HK) Ltd.

www.tuttlepublishing.com

Originally published as DEFORME CHARA NO EGAKIKATA
Copyright © Ryusuke Hamamoto 2016
English translation rights arranged with Genkosha Co., Ltd.
through Japan UNI Agency, Inc., Tokyo

English Translation © 2020 Periplus Editions (HK) Ltd.

All rights reserved. No part of this publication may be
reproduced or utilized in any form or by any means, electronic
or mechanical, including photocopying, recording, or by any
information storage and retrieval system, without prior
written permission from the publisher.

Library of Congress Cataloging-in-Publication Data in process

ISBN 978-4-8053-1607-8

Distributed by

North America, Latin America & Europe
Tuttle Publishing
364 Innovation Drive
North Clarendon, VT 05759-9436 U.S.A.
Tel: 1 (802) 773-8930; Fax: 1 (802) 773-6993
info@tuttlepublishing.com
www.tuttlepublishing.com

Japan
Tuttle Publishing
Yaekari Building, 3rd Floor
5-4-12 Osaki
Shinagawa-ku
Tokyo 141 0032
Tel: (81) 3 5437-0171; Fax: (81) 3 5437-0755
sales@tuttle.co.jp
www.tuttle.co.jp

Asia Pacific
Berkeley Books Pte. Ltd.
3 Kallang Sector, #04-01
Singapore 349278
Tel: (65) 67412178; Fax: (65) 67412179
inquiries@periplus.com.sg
www.tuttlepublishing.com

25 24 23 22 11 10 9 8 7 6

Printed in China 2204EP

TUTTLE PUBLISHING® is a registered trademark of
Tuttle Publishing, a division of Periplus Editions (HK) Ltd.

"Books to Span the East and West"

Tuttle Publishing was founded in 1832 in the
small New England town of Rutland, Vermont
[USA]. Our core values remain as strong today as
they were then—to publish best-in-class books
which bring people together one page at a time.
In 1948, we established a publishing office in
Japan—and Tuttle is now a leader in publishing
English-language books about the arts, languages
and cultures of Asia. The world has become a
much smaller place today and Asia's economic
and cultural influence has grown. Yet the need
for meaningful dialogue and information about
this diverse region has never been greater. Over
the past seven decades, Tuttle has published
thousands of books on subjects ranging from
martial arts and paper crafts to language
learning and literature—and our talented authors,
illustrators, designers and photographers have
won many prestigious awards. We welcome you
to explore the wealth of information available on
Asia at **www.tuttlepublishing.com**.